Mythical Mandalas

50 Fantastic Designs

Copyright 2019

50 artistically designed mandalas of varying complexity, fashioned to grab the attention of colorists of all ages and skill levels.

These fantastic compositions will not only provide hours of coloring enjoyment, but will boost your creativity, inspire inner harmony and create relaxation and relieve tension easing your mind, body and soul.

Each design is printed on one single-sided page and has a place at the bottom of each page to record calming thoughts and/or positive affirmations.

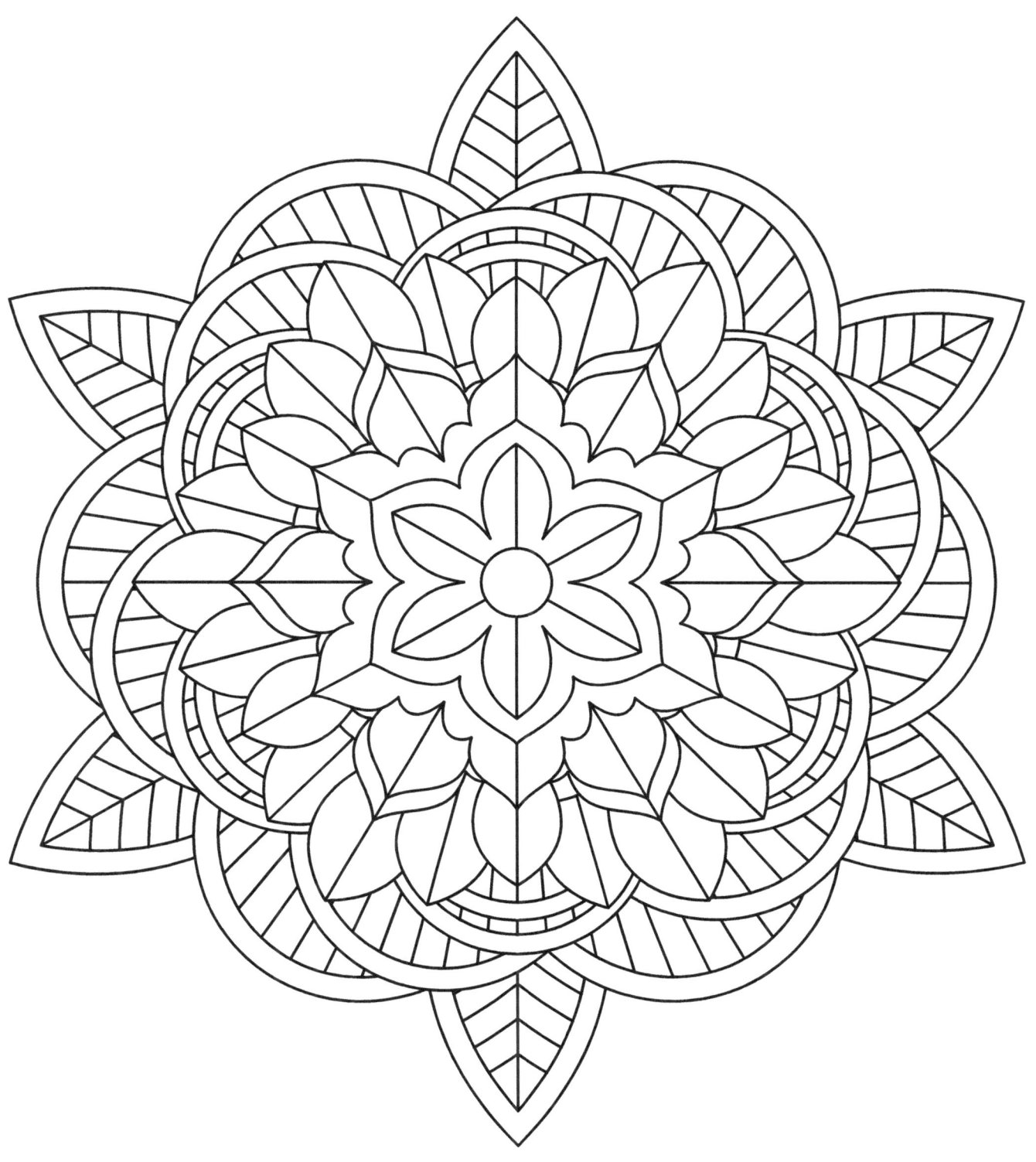

Calming Thoughts/Positive Affirmation:

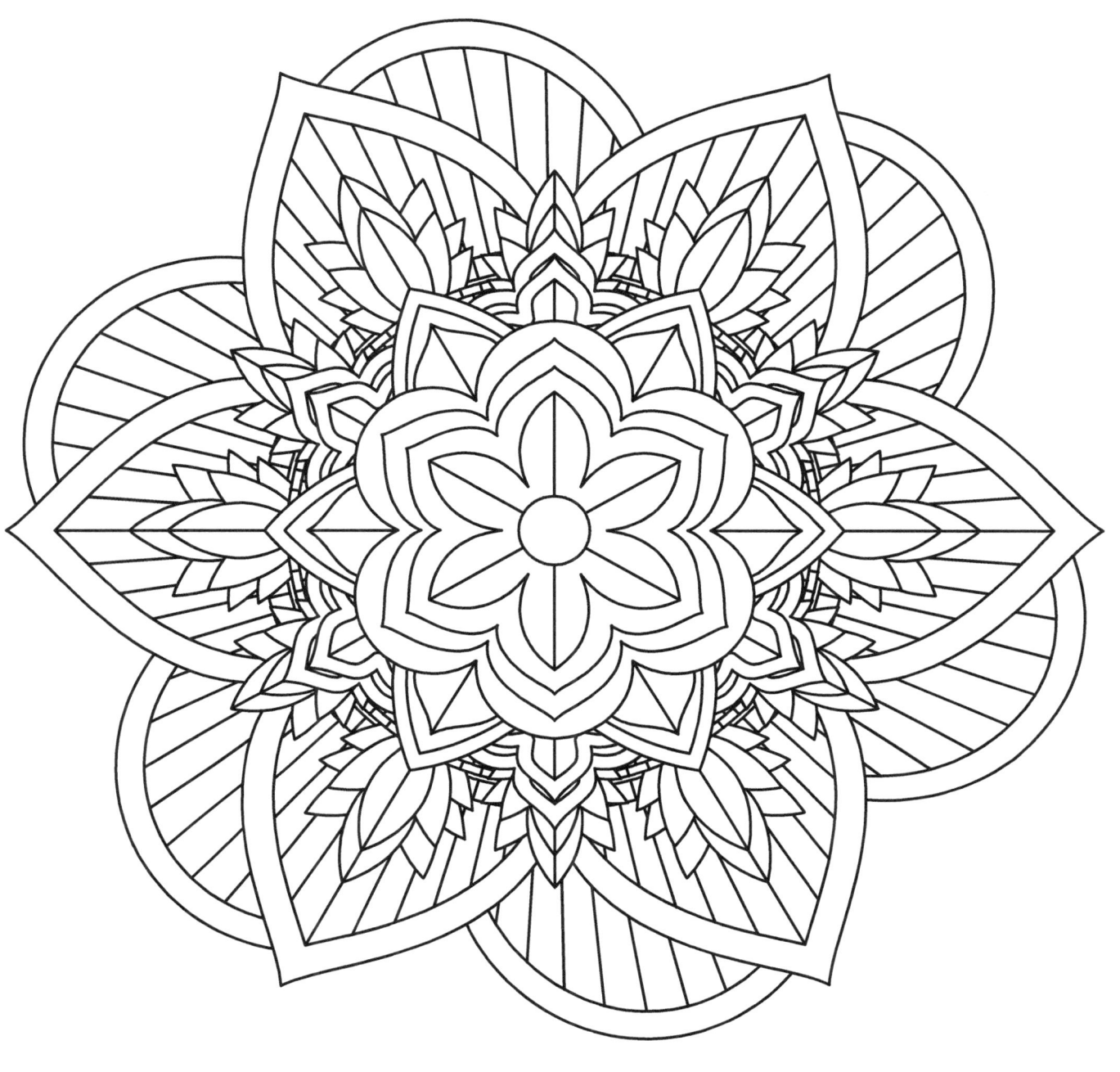

Calming Thoughts/Positive Affirmation:

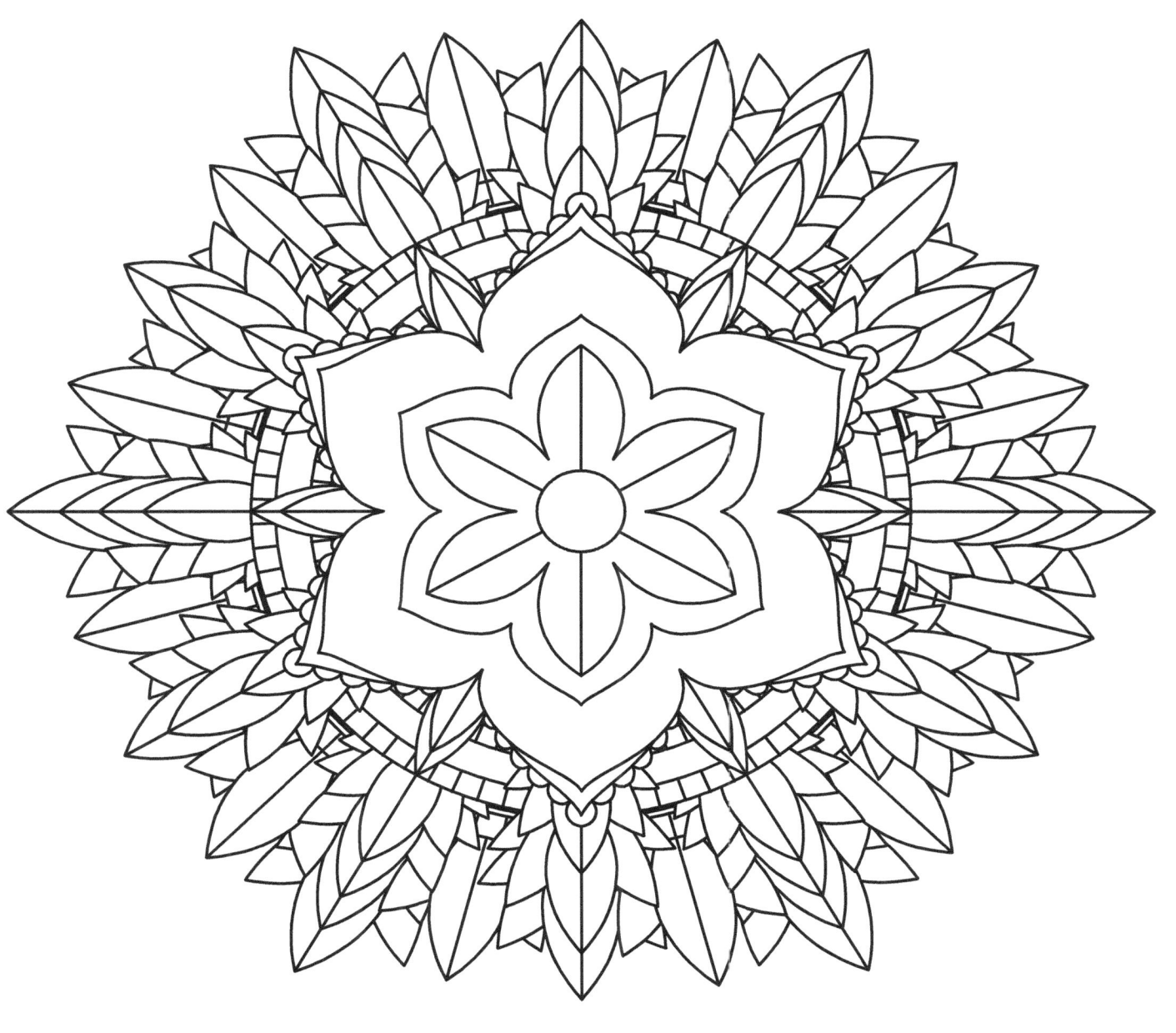

Calming Thoughts/Positive Affirmation:

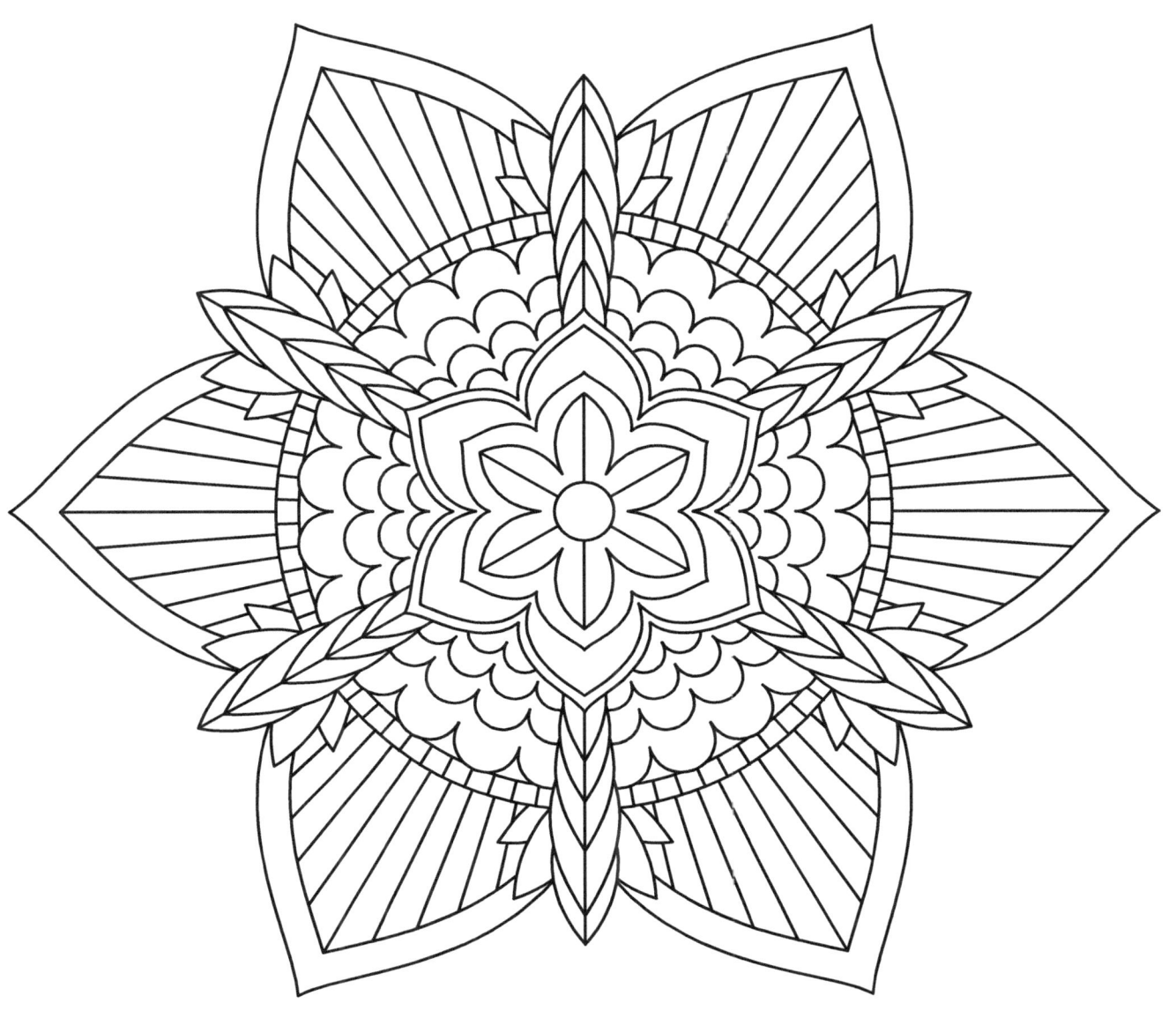

Calming Thoughts/Positive Affirmation:

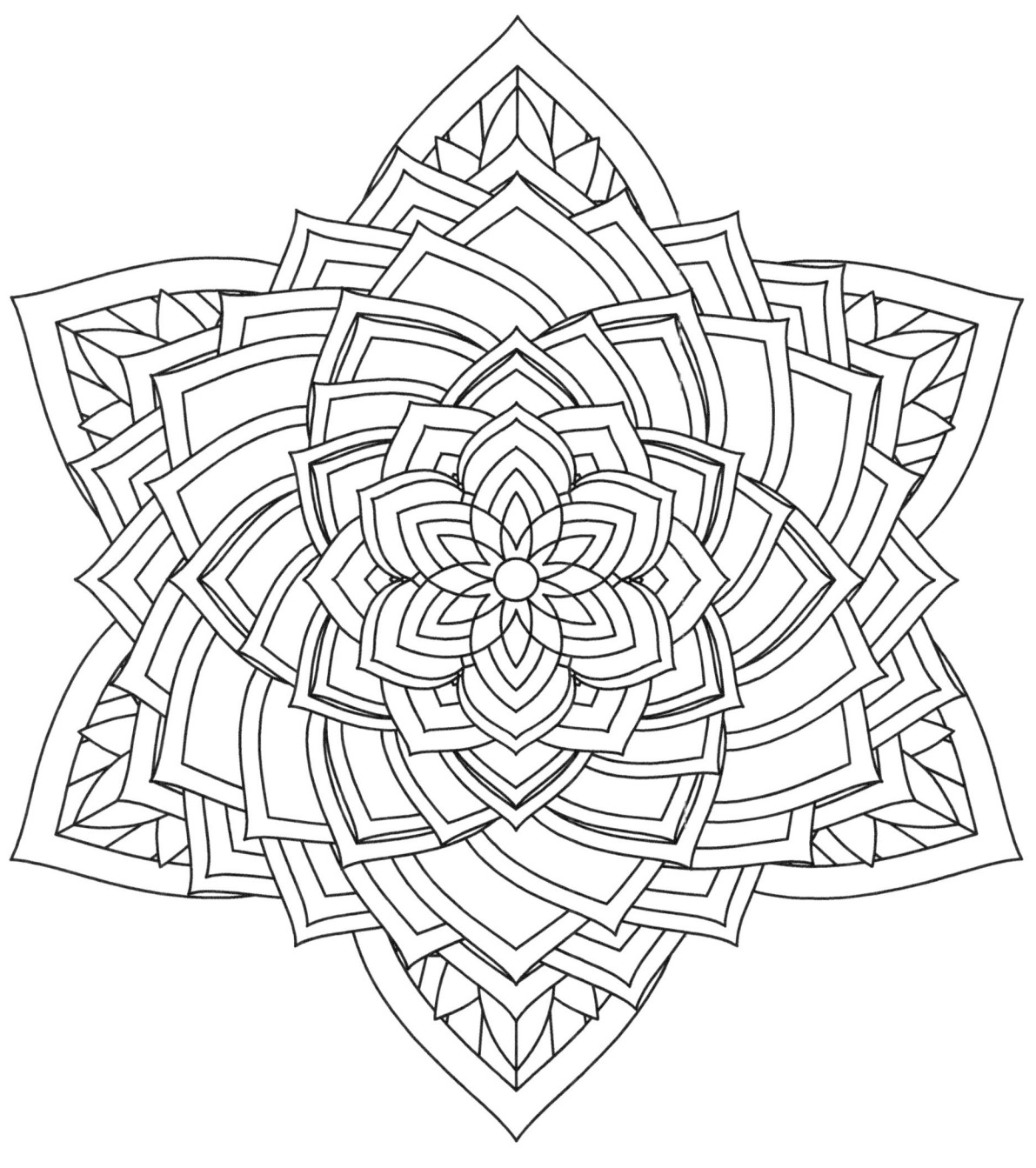

Calming Thoughts/Positive Affirmation:

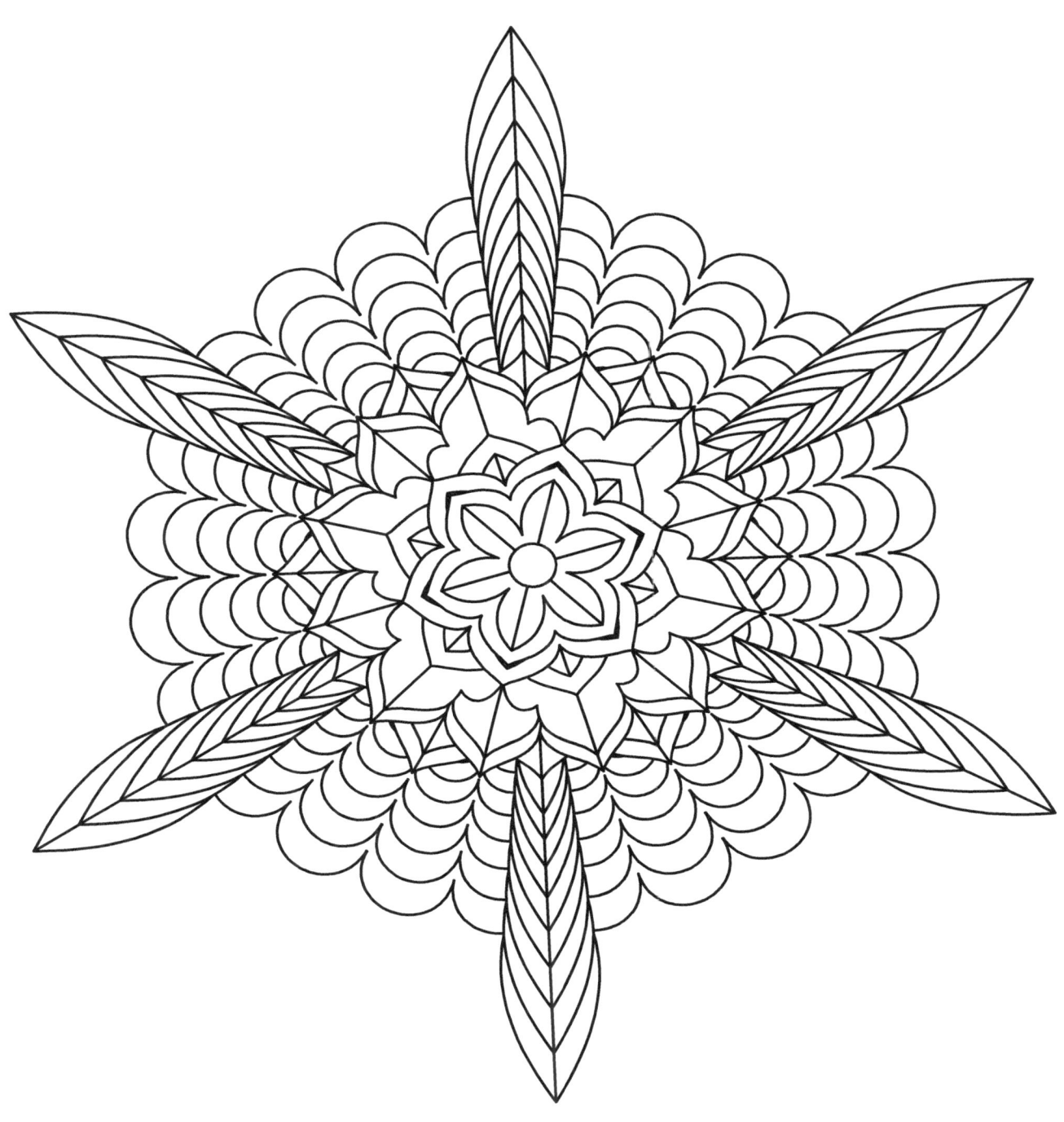

Calming Thoughts/Positive Affirmation:

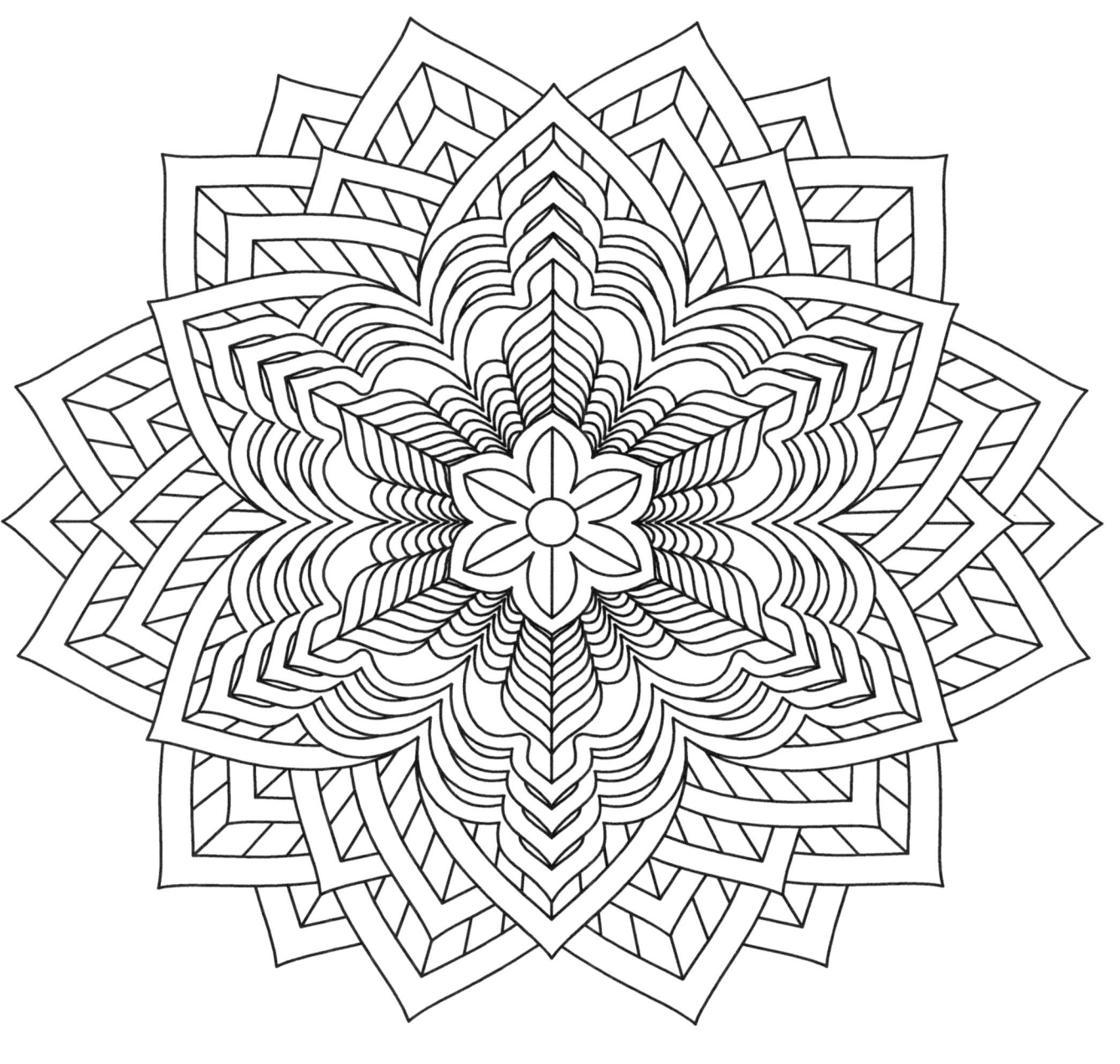

Calming Thoughts/Positive Affirmation:

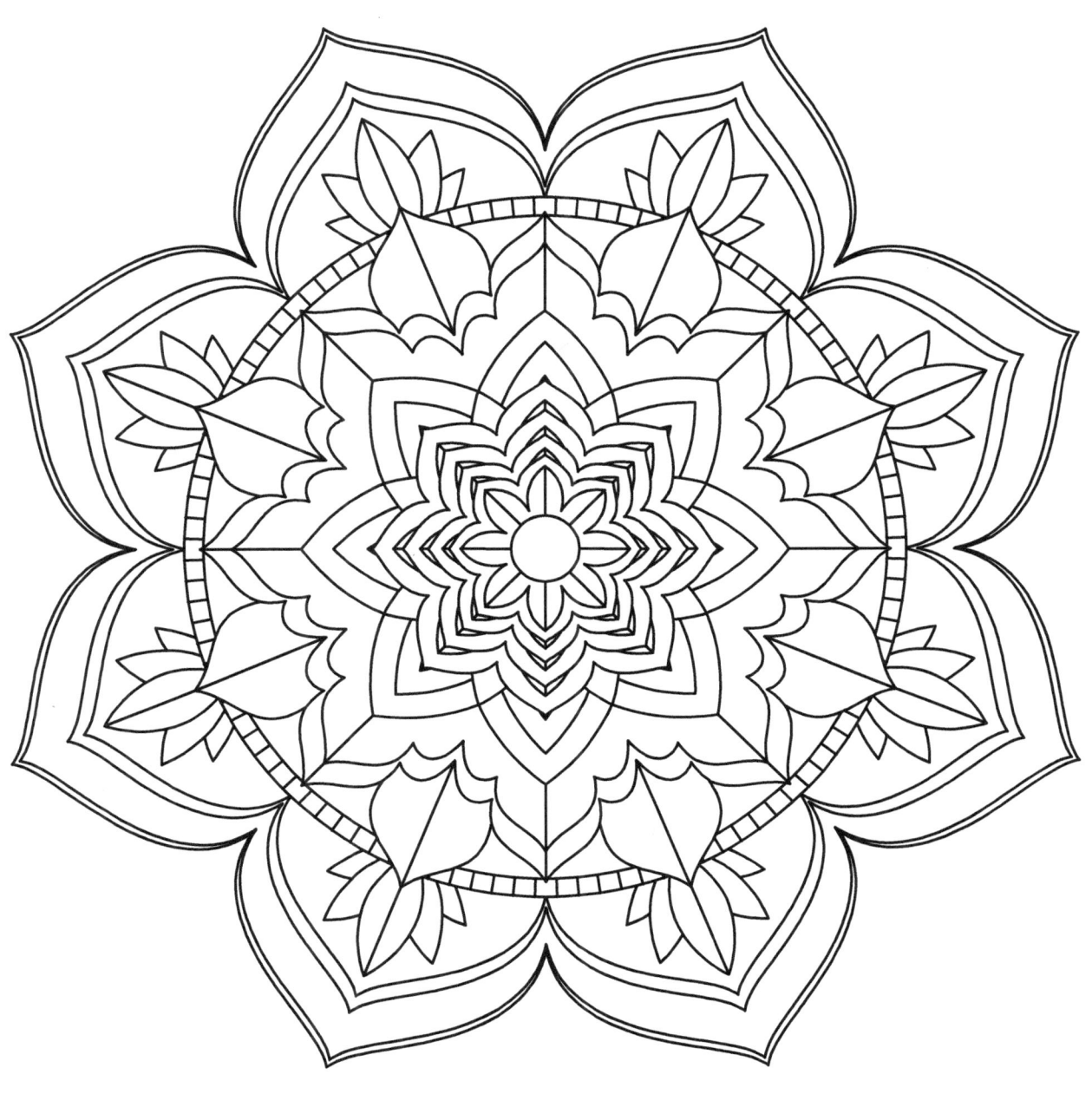

Calming Thoughts/Positive Affirmation:

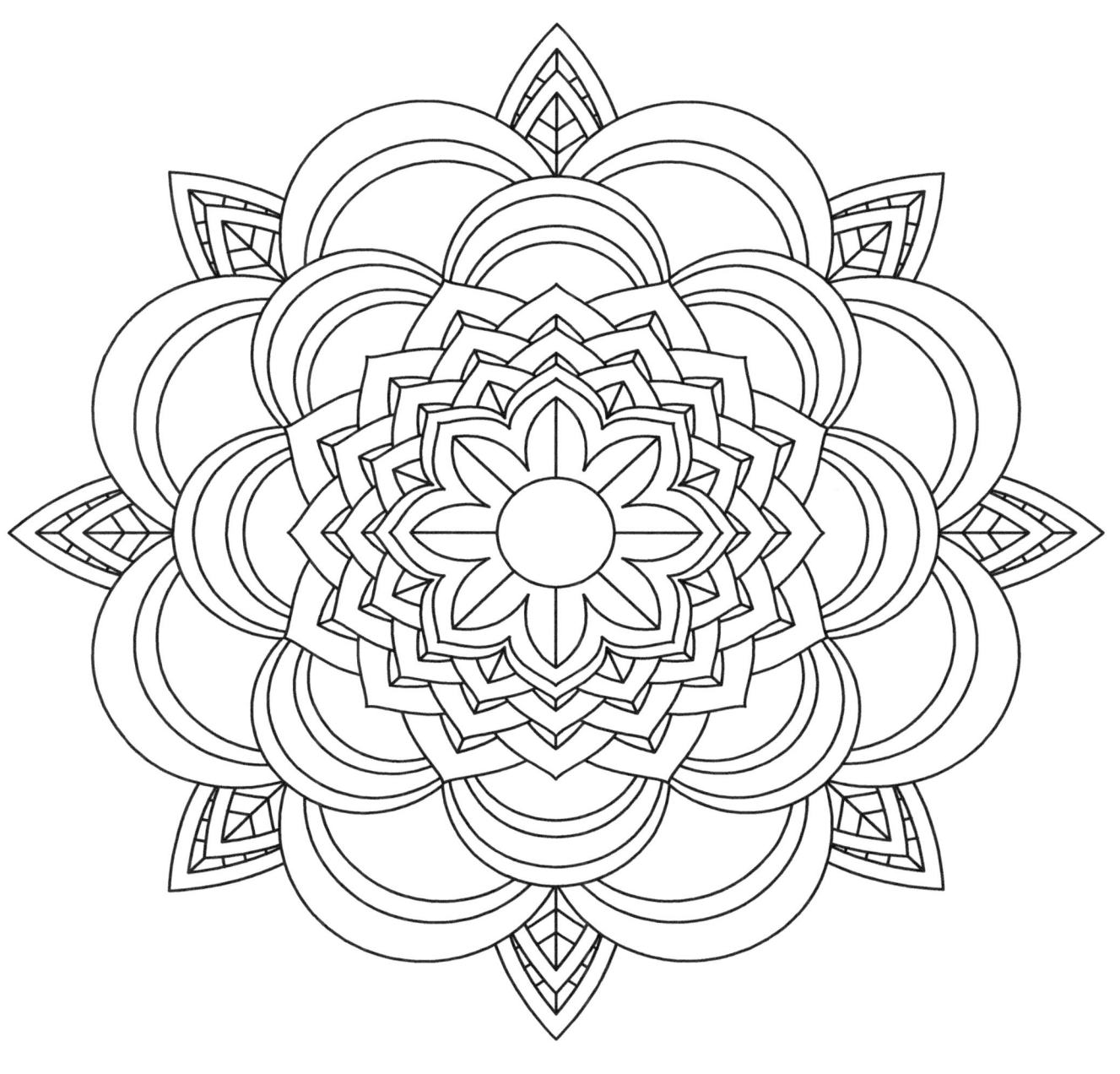

Calming Thoughts/Positive Affirmation:

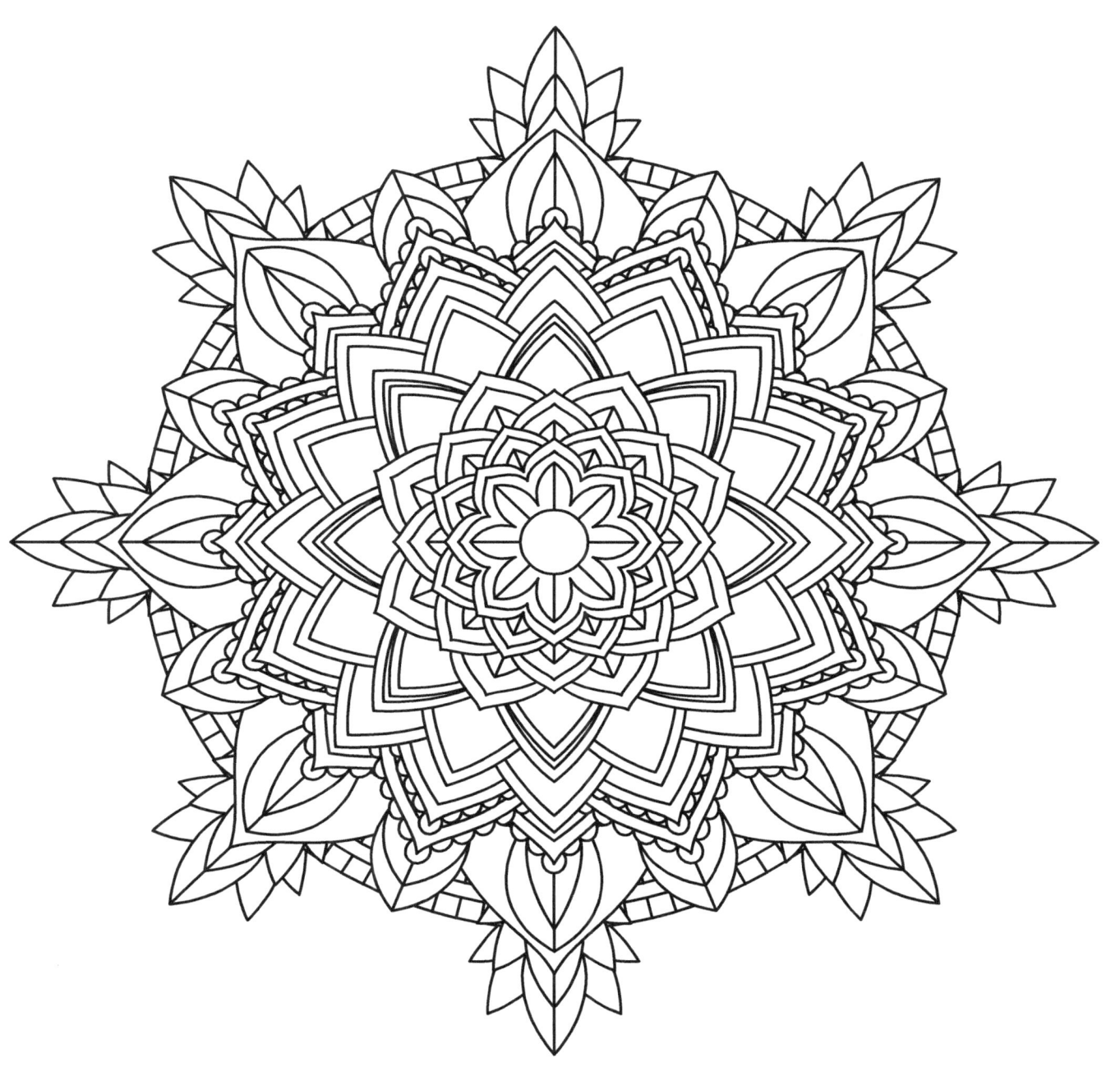

Calming Thoughts/Positive Affirmation:

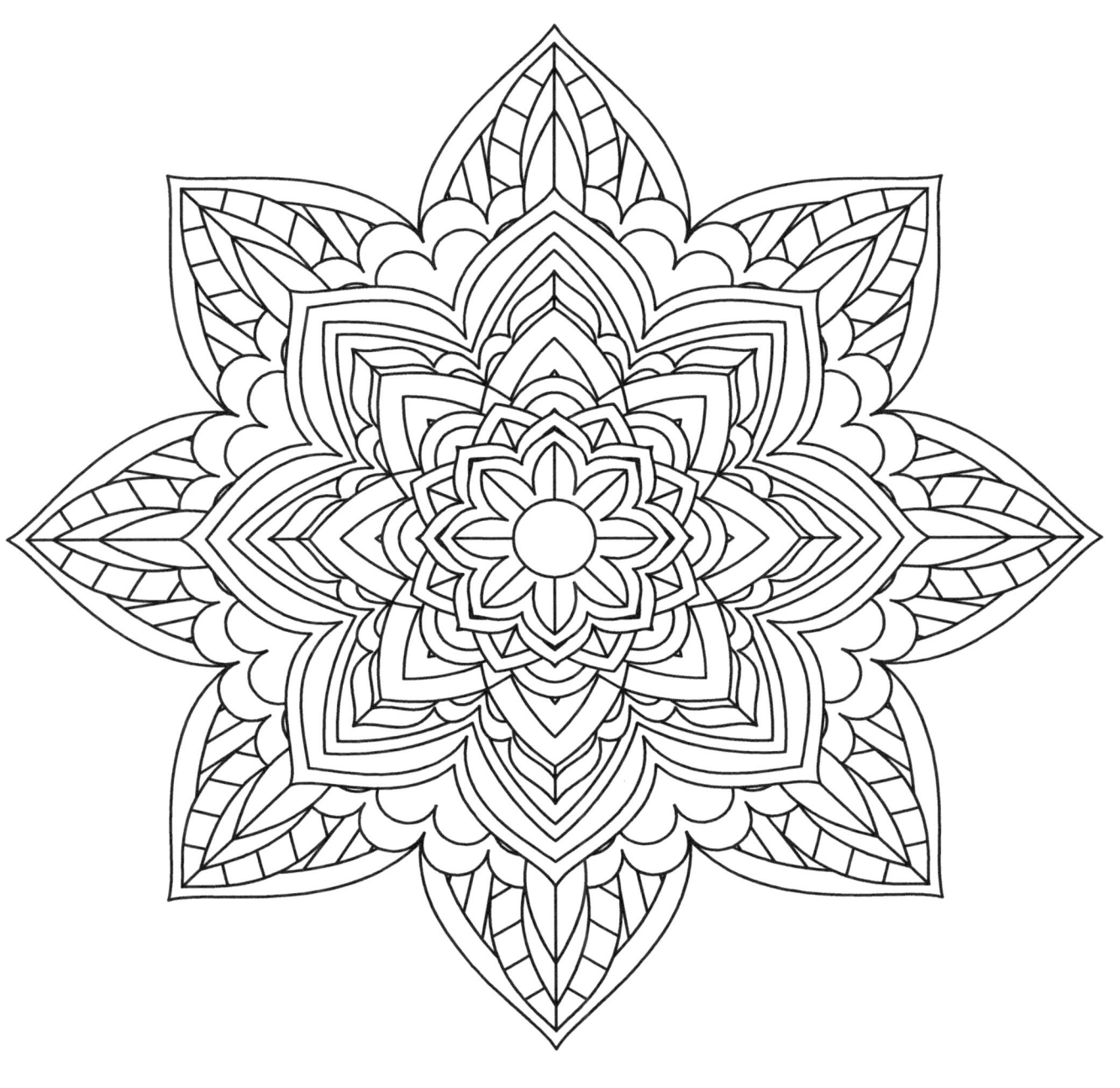

Calming Thoughts/Positive Affirmation:

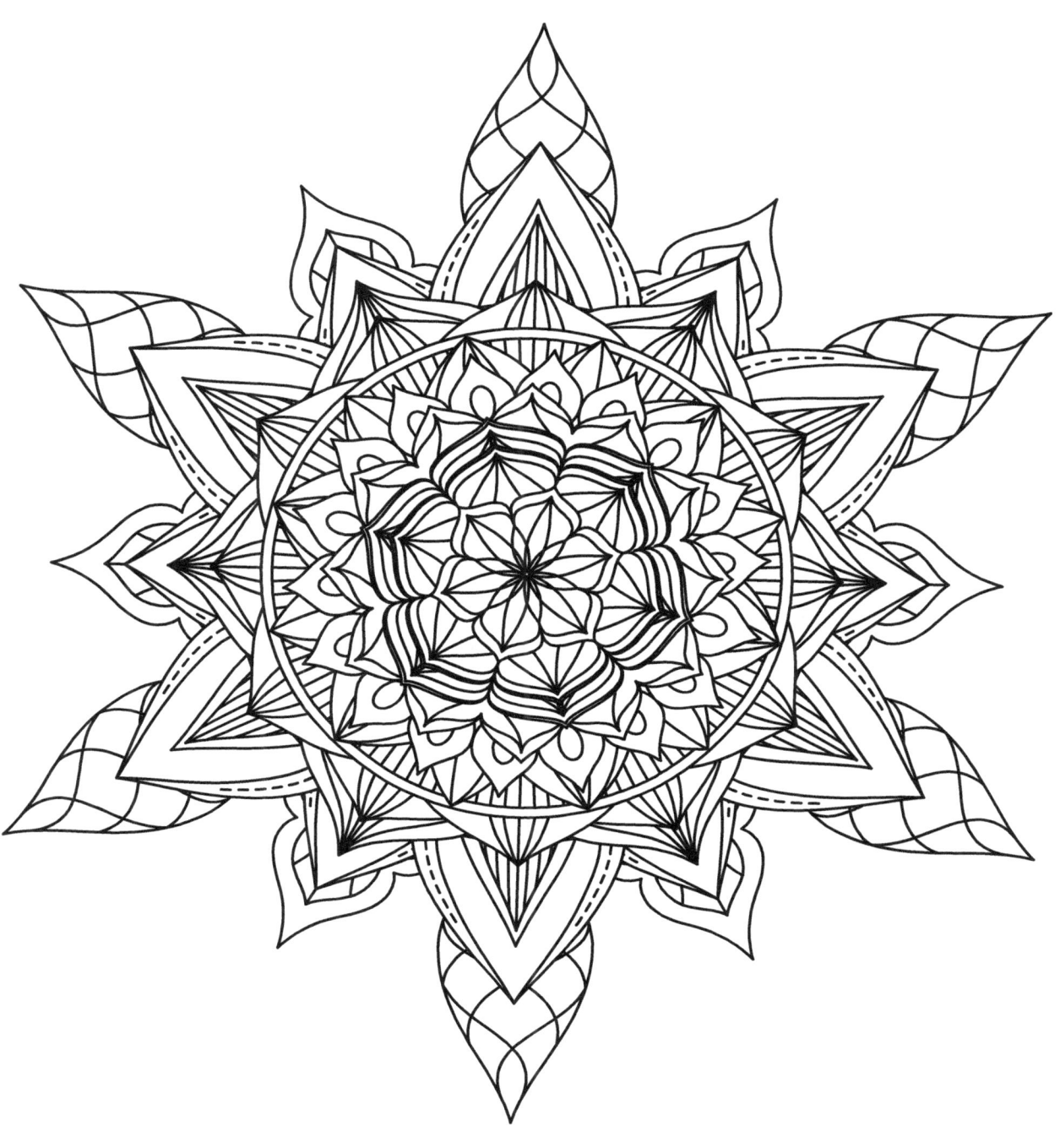

Calming Thoughts/Positive Affirmation:

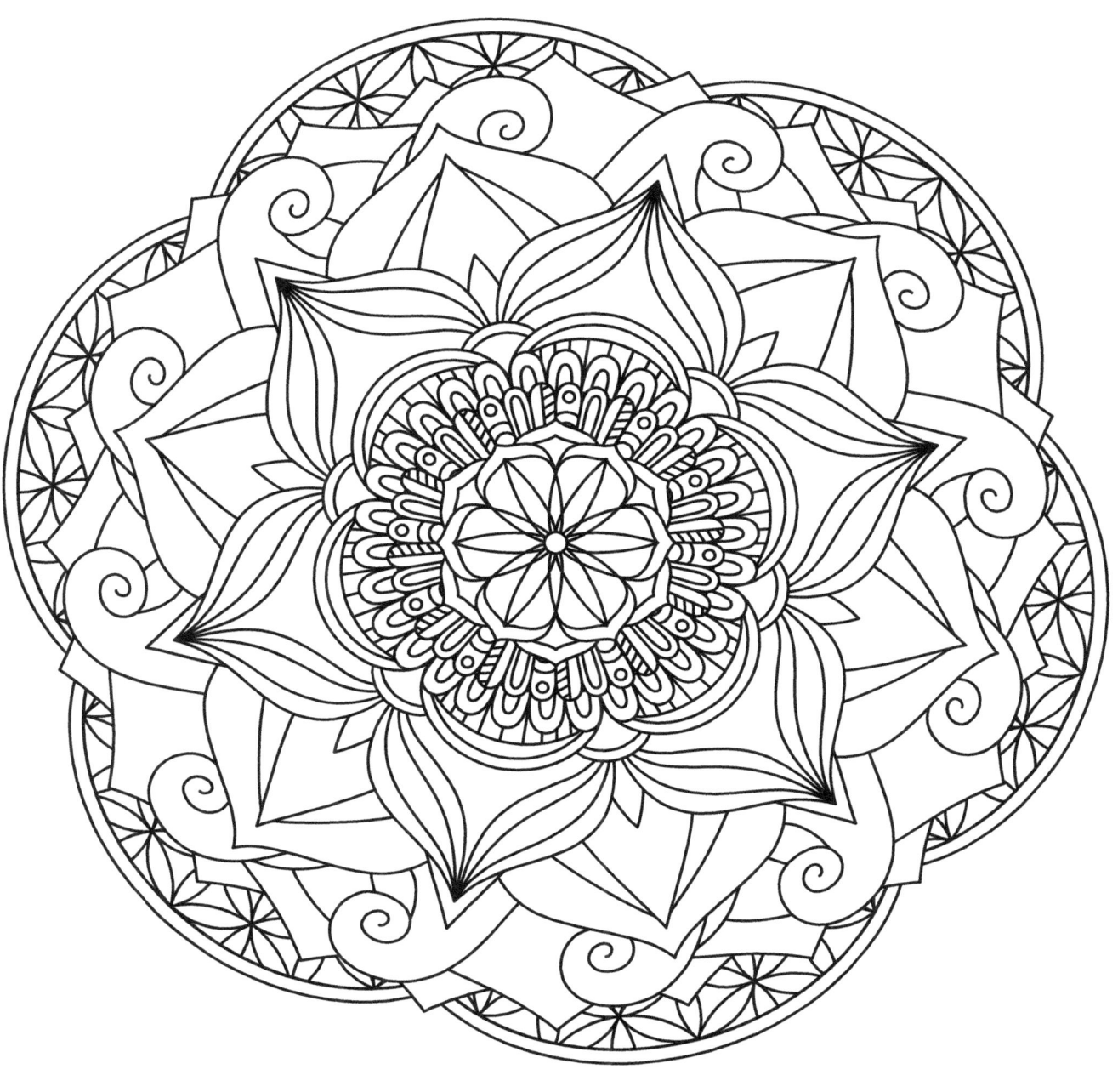

Calming Thoughts/Positive Affirmation:

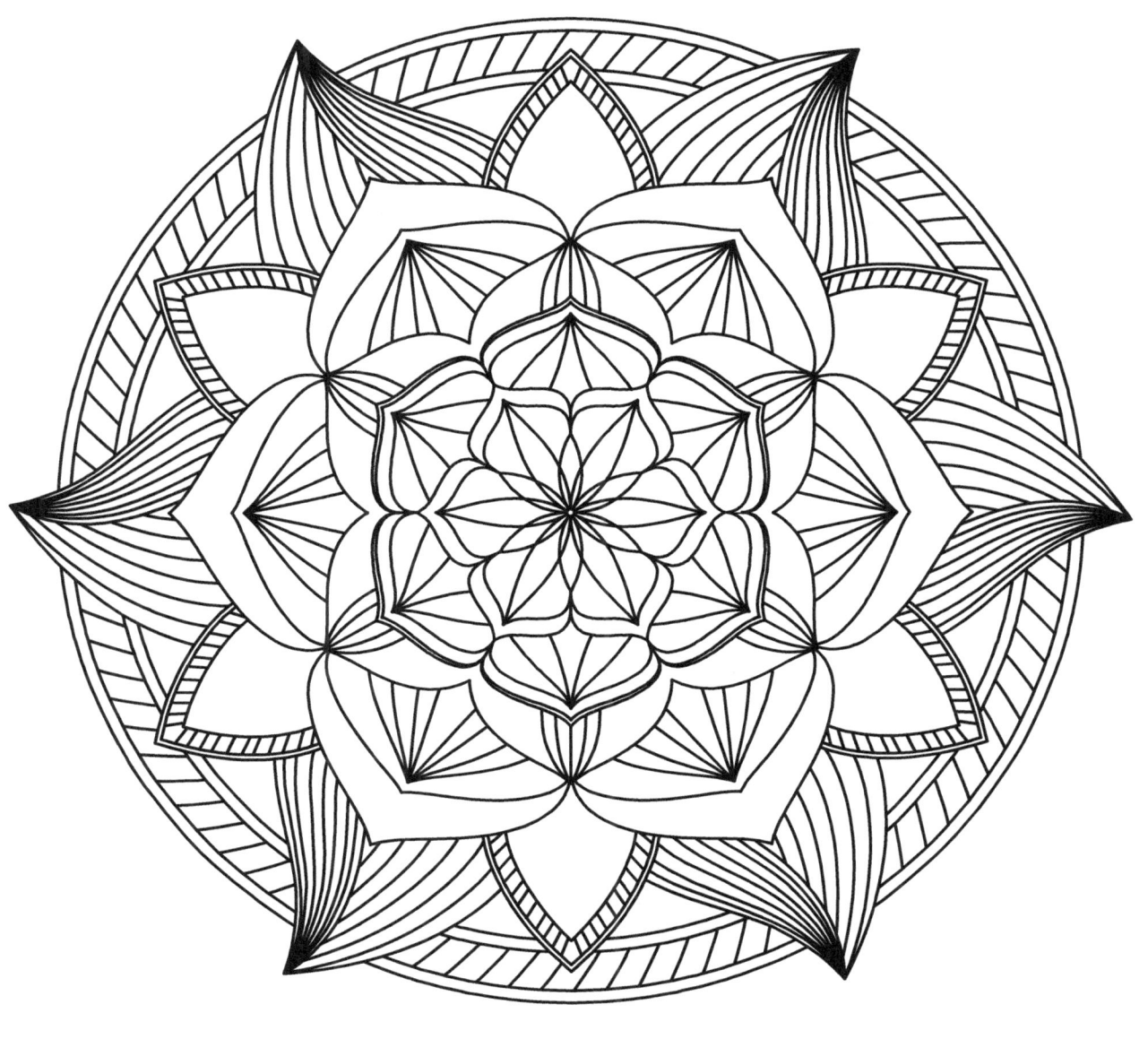

Calming Thoughts/Positive Affirmation:

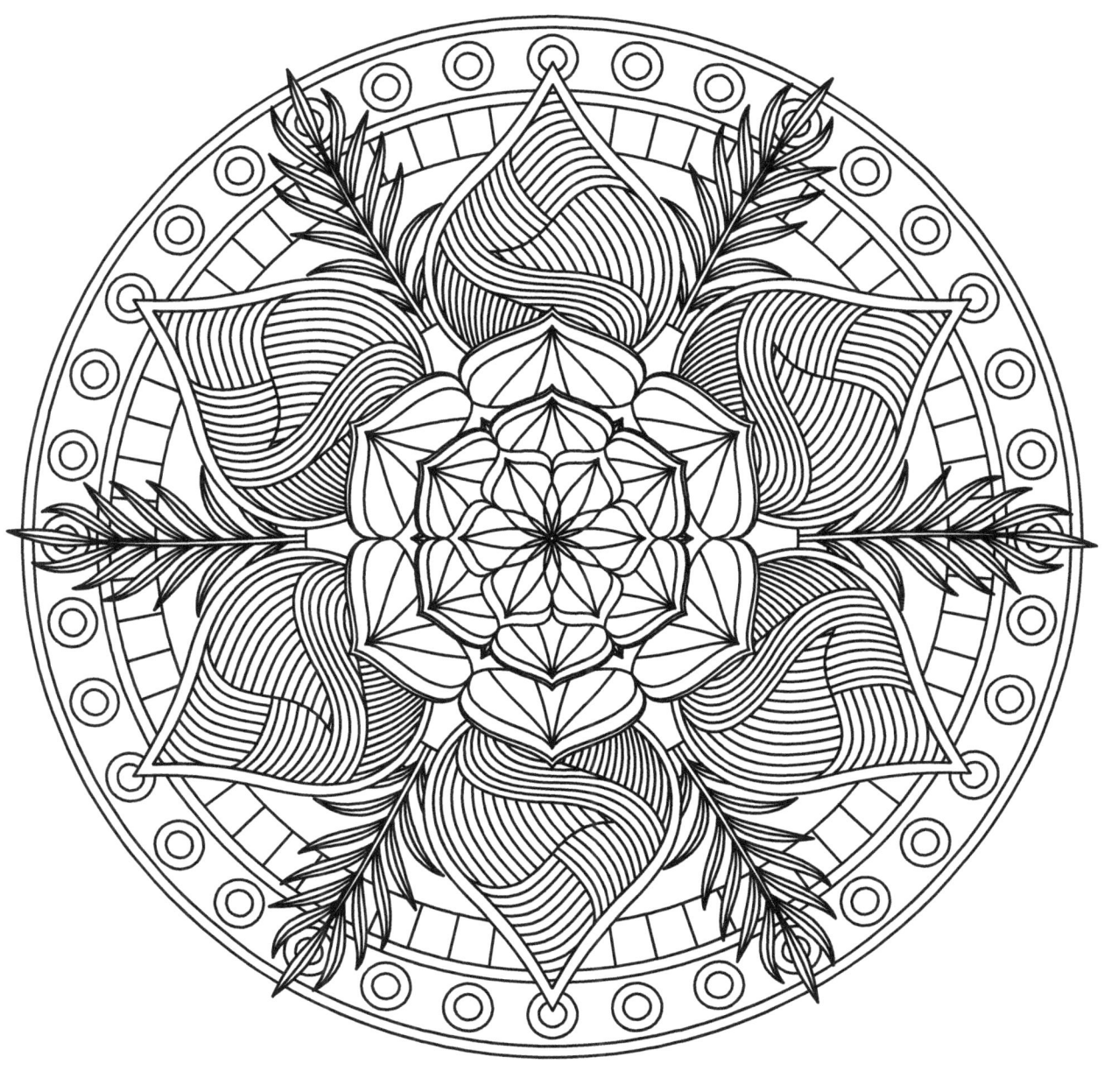

Calming Thoughts/Positive Affirmation:

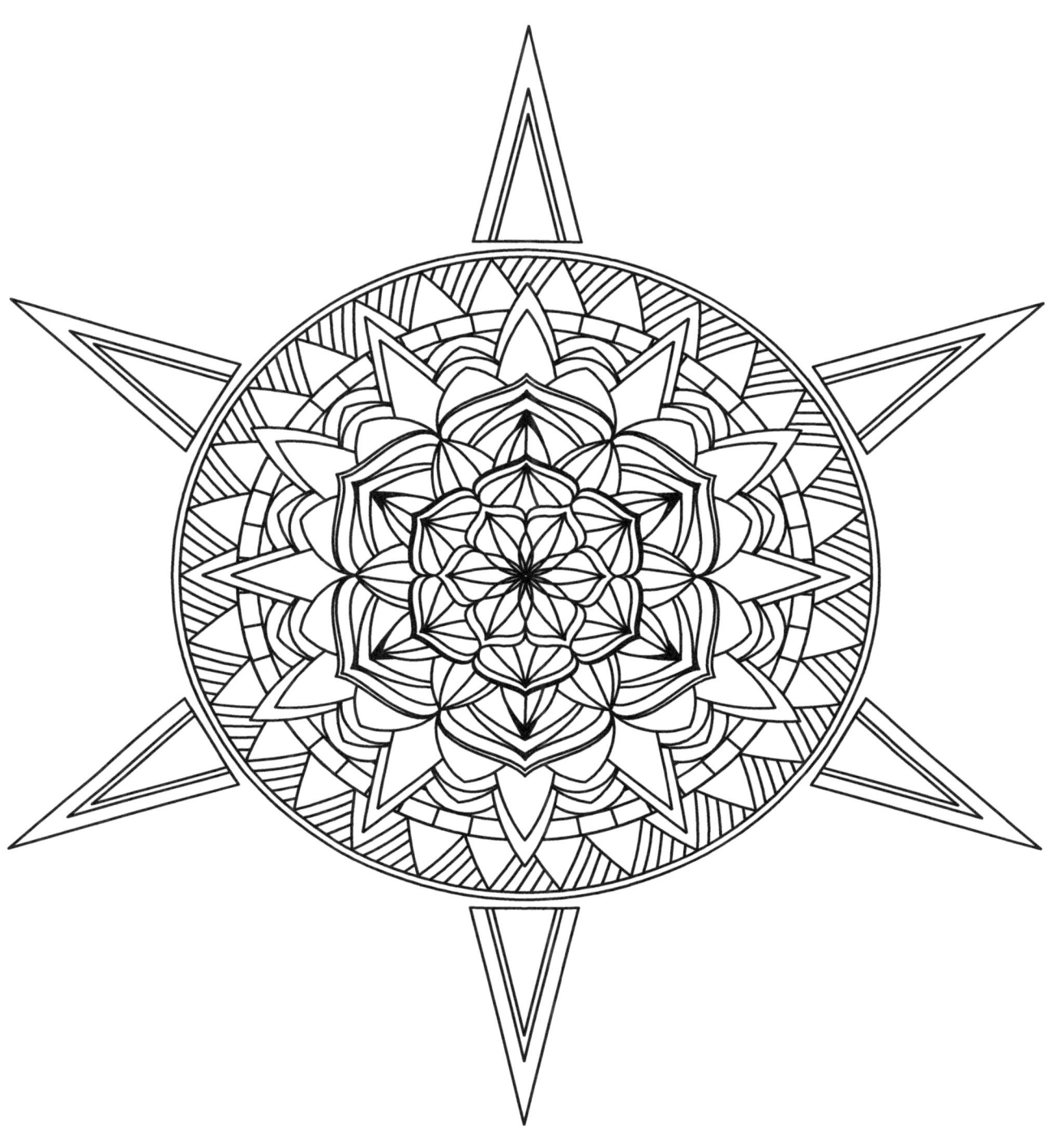

Calming Thoughts/Positive Affirmation:

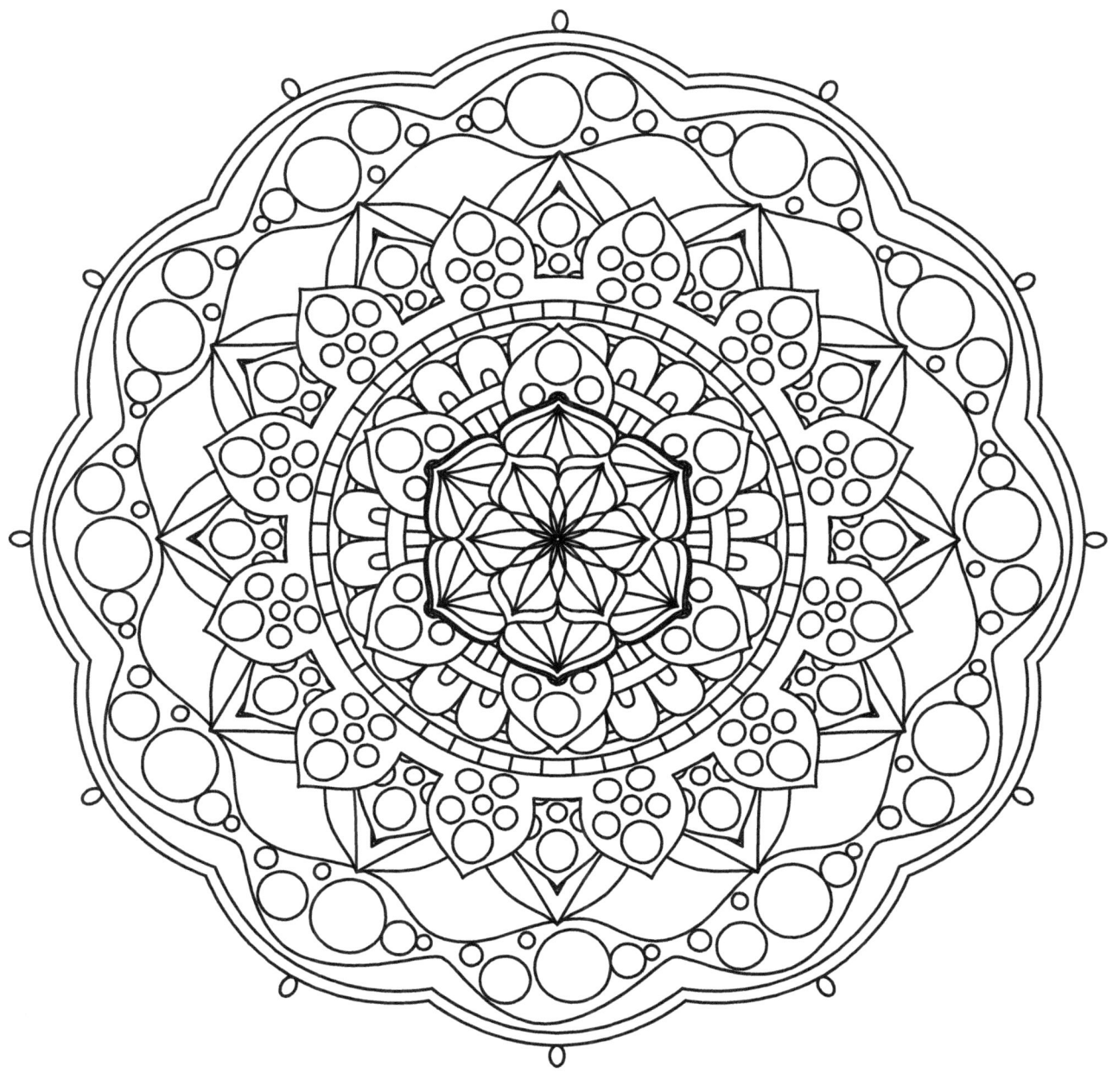

Calming Thoughts/Positive Affirmation:

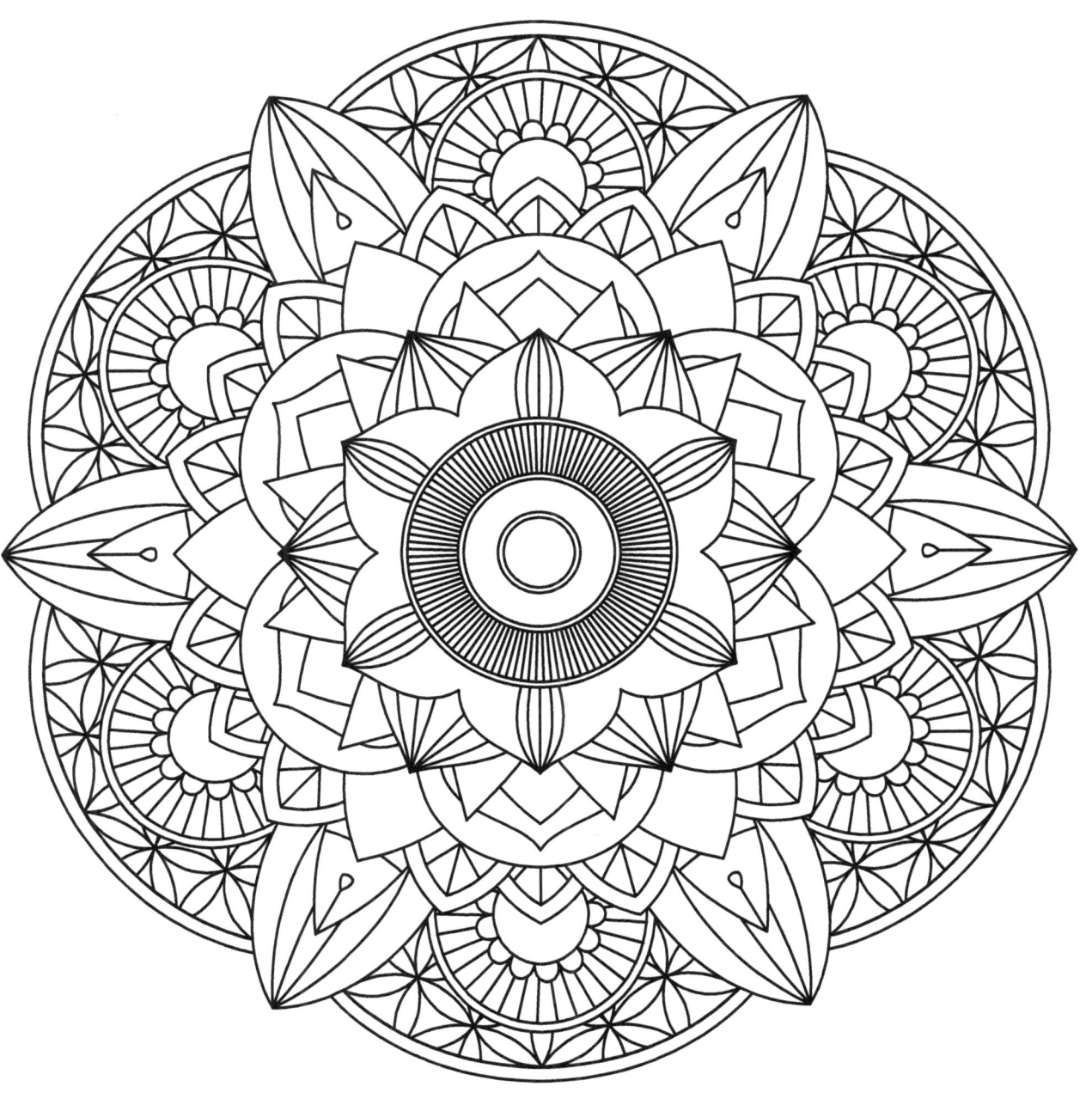

Calming Thoughts/Positive Affirmation:

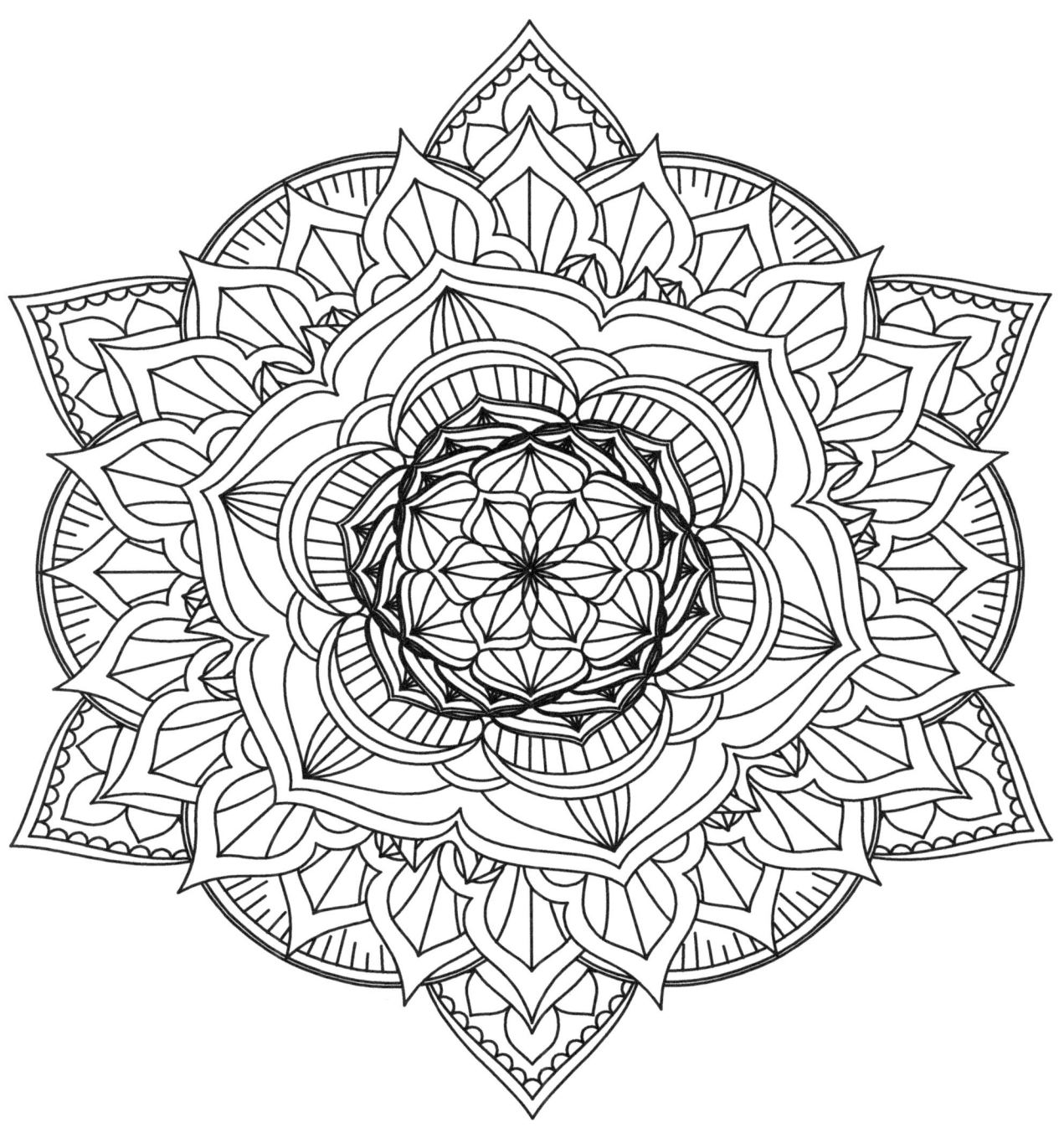

Calming Thoughts/Positive Affirmation:

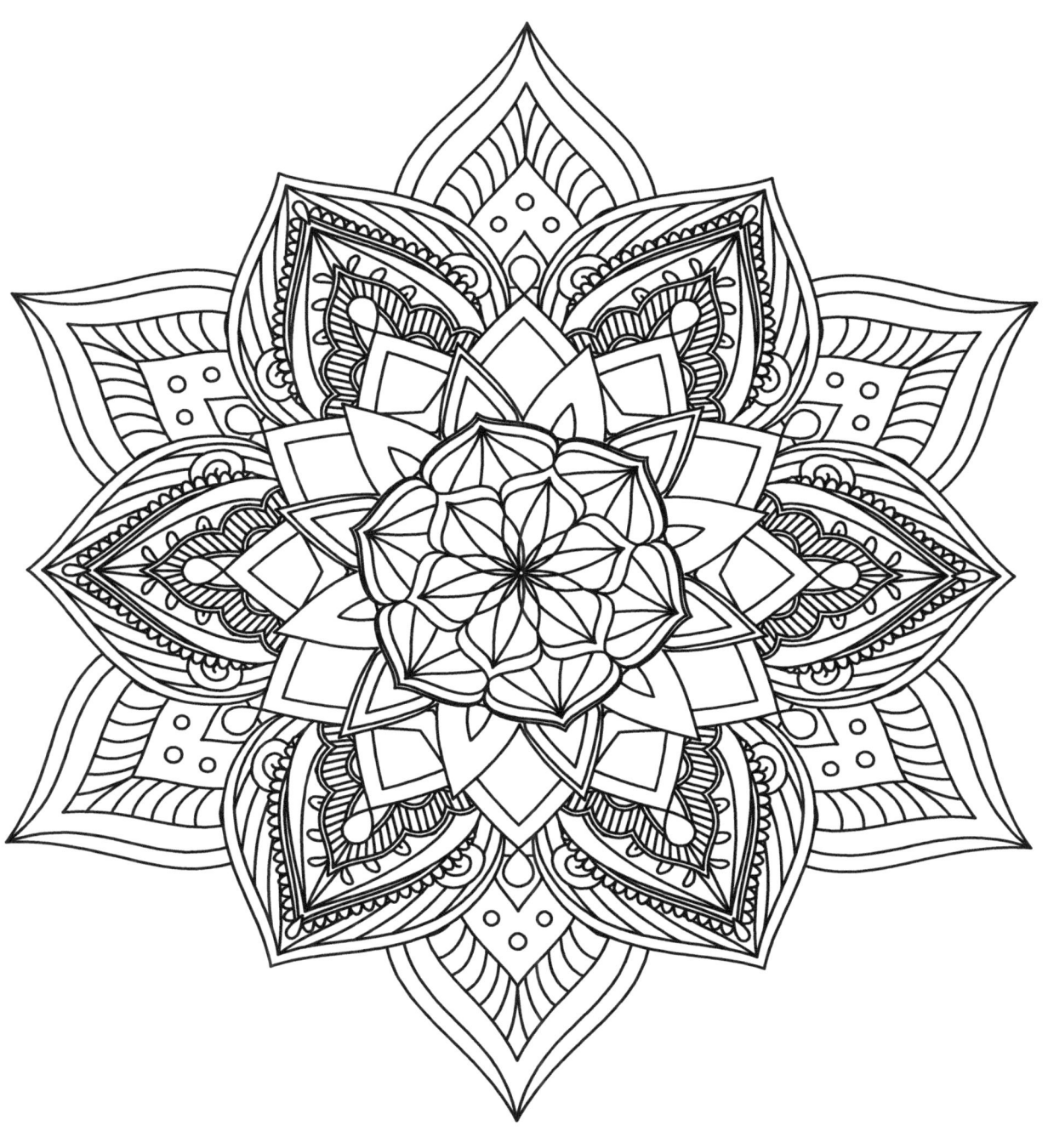

Calming Thoughts/Positive Affirmation:

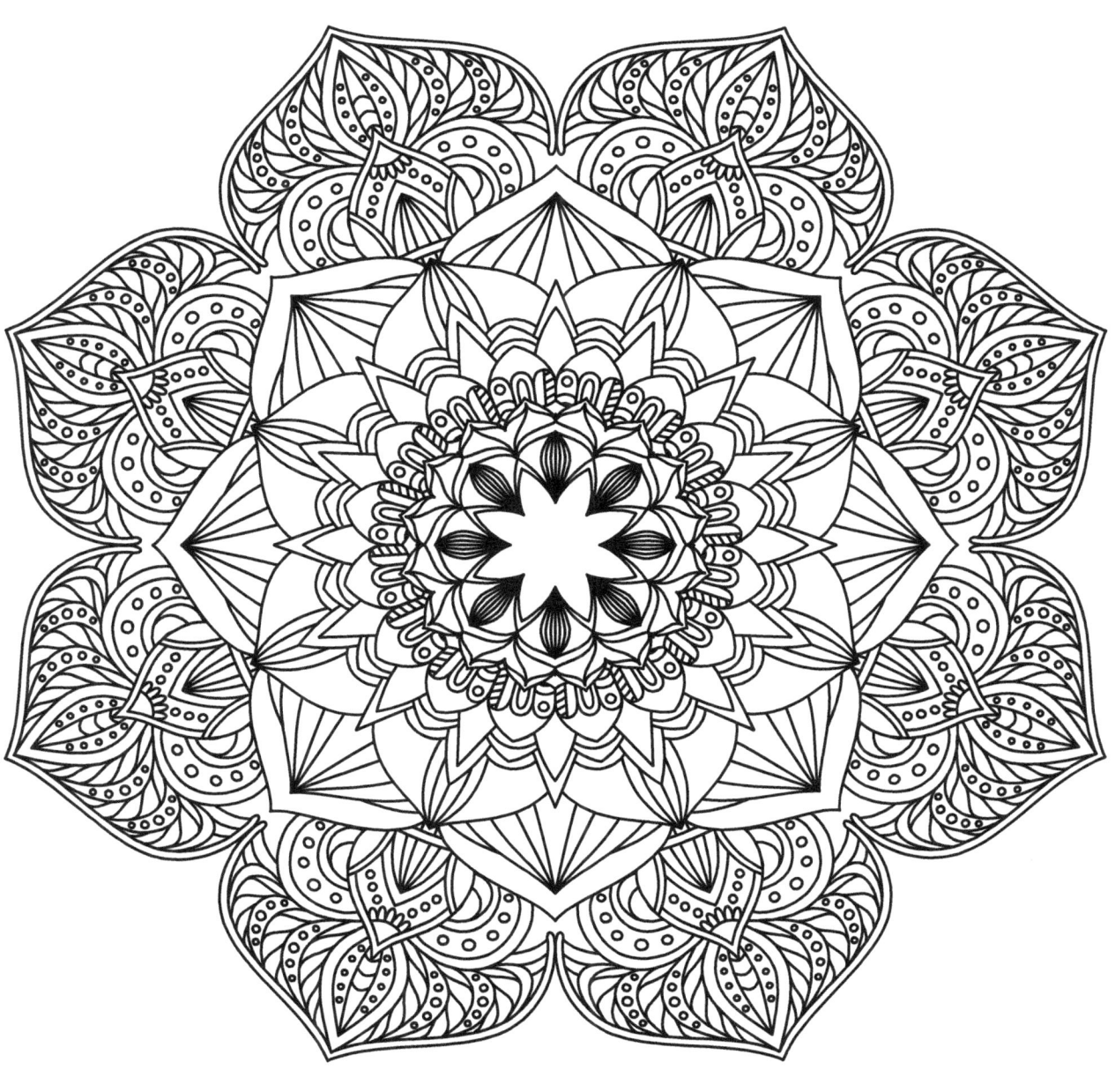

Calming Thoughts/Positive Affirmation:

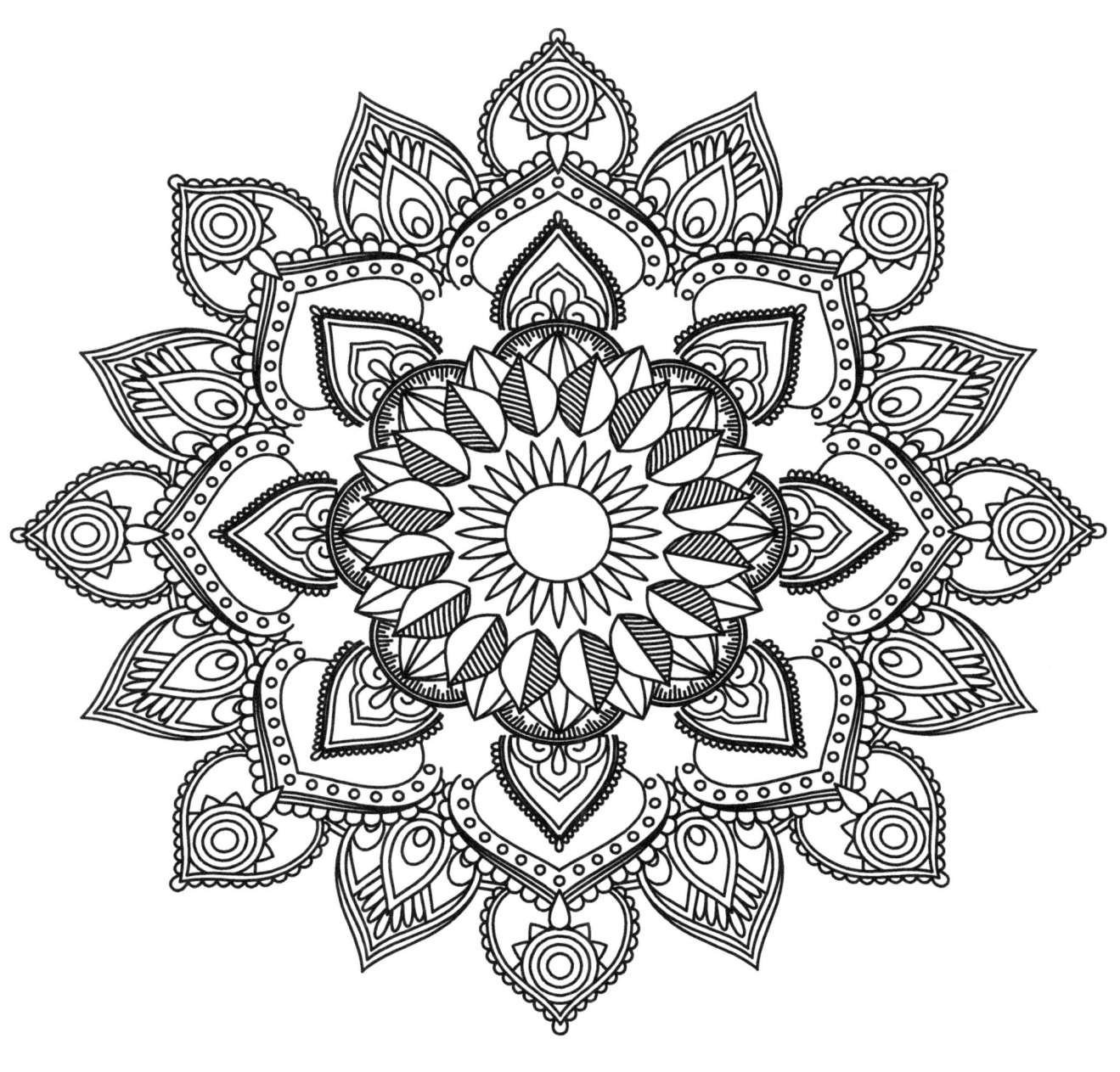

Calming Thoughts/Positive Affirmation:

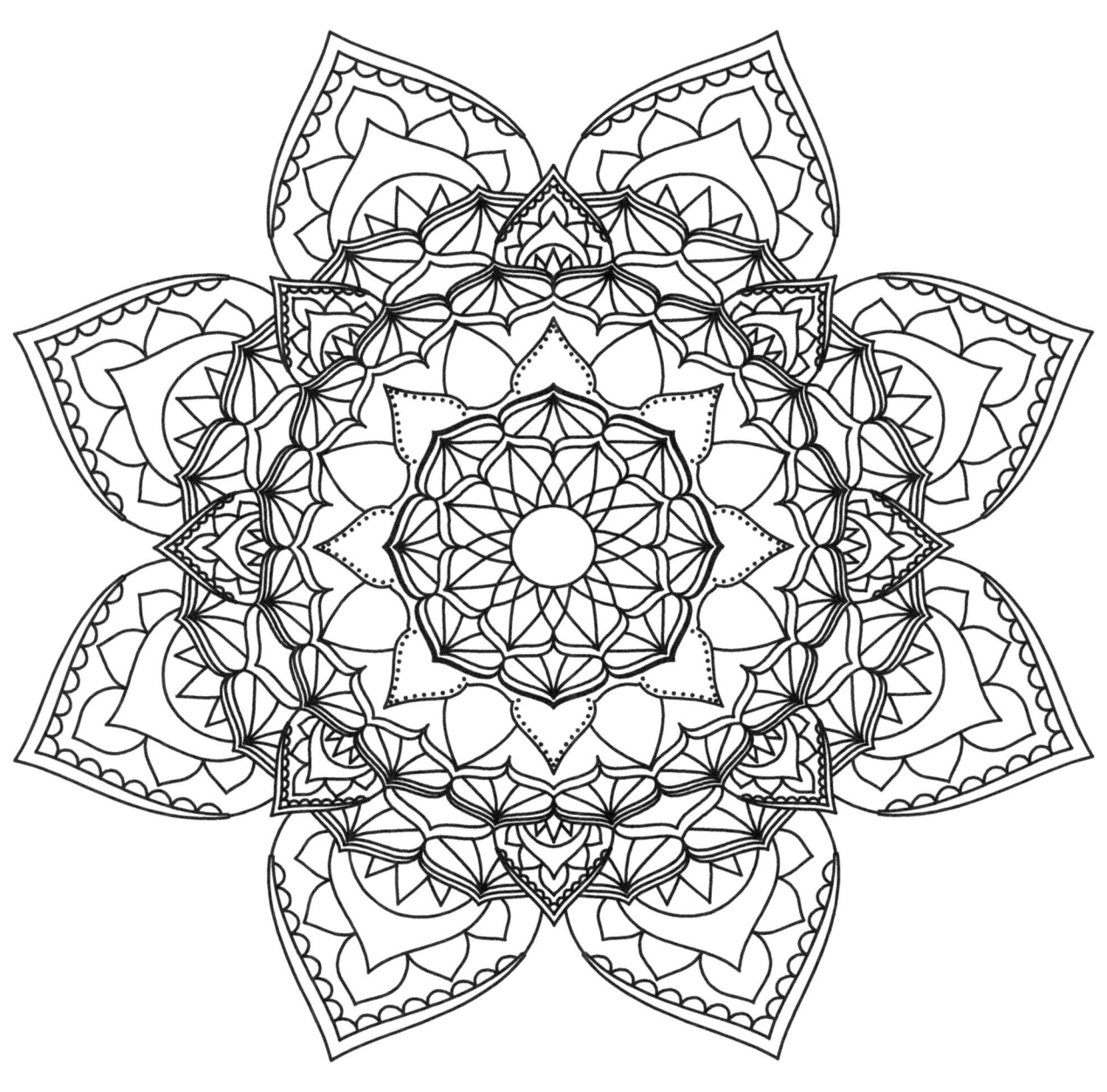

Calming Thoughts/Positive Affirmation:

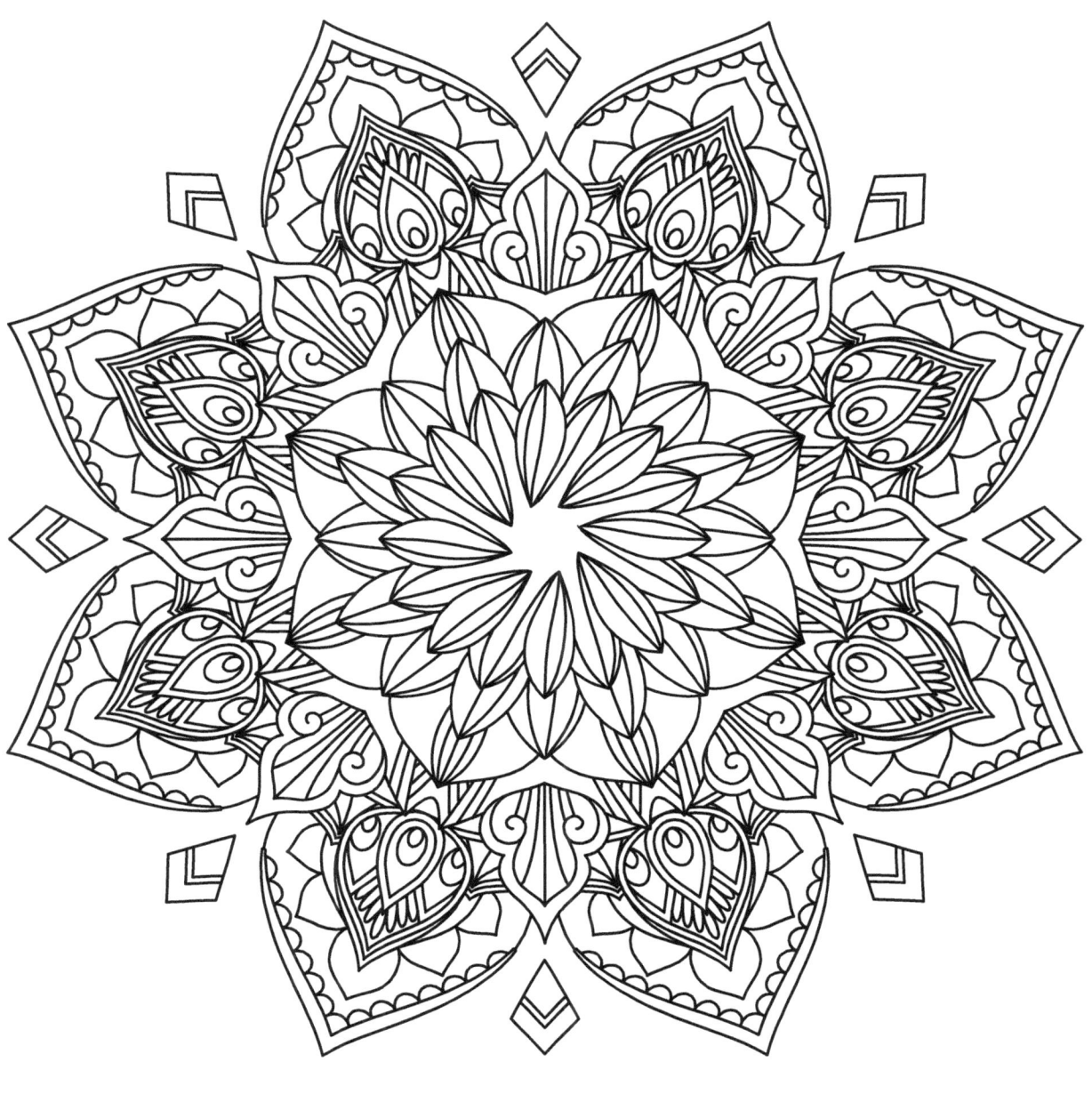

Calming Thoughts/Positive Affirmation:

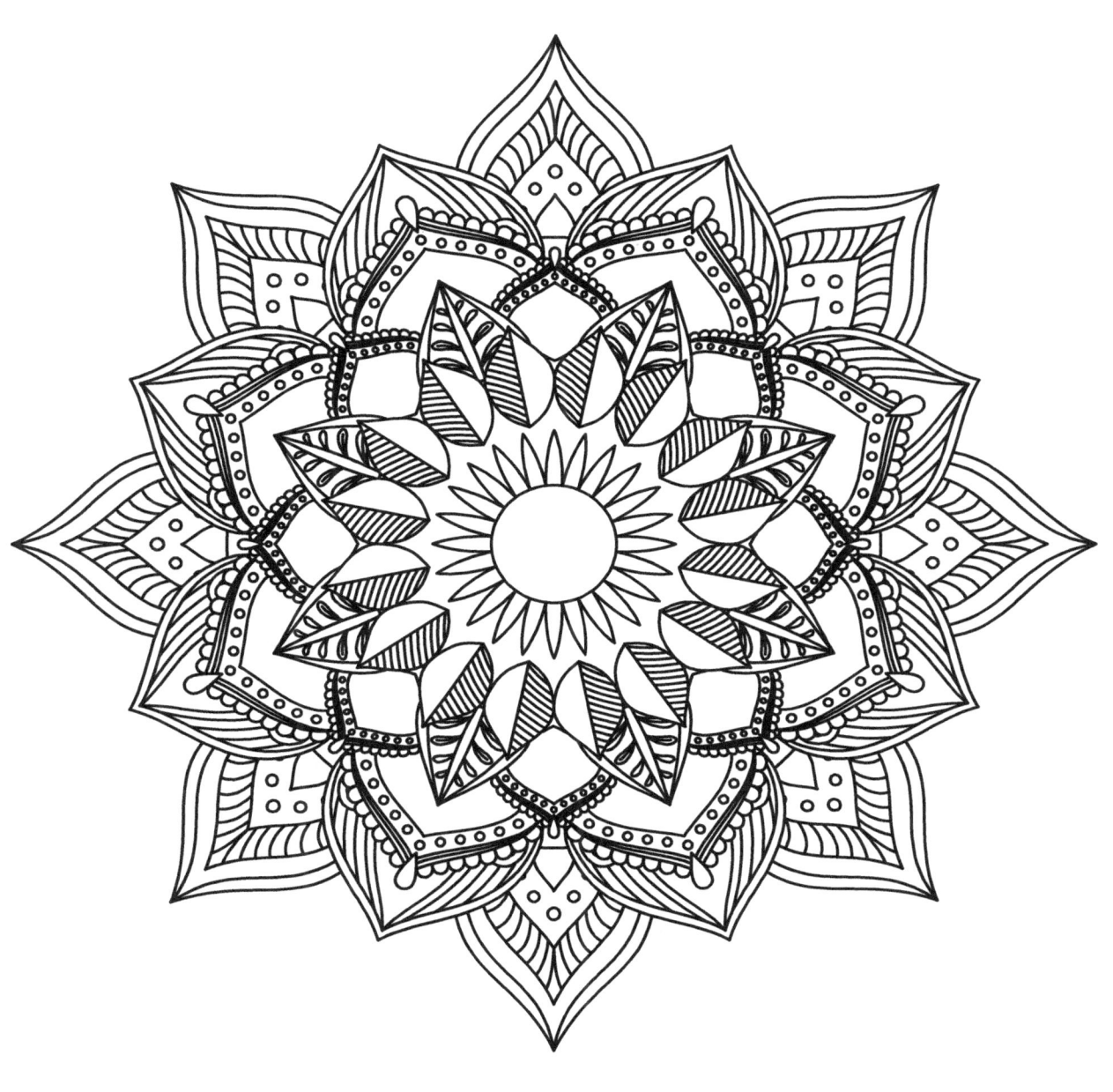

Calming Thoughts/Positive Affirmation:

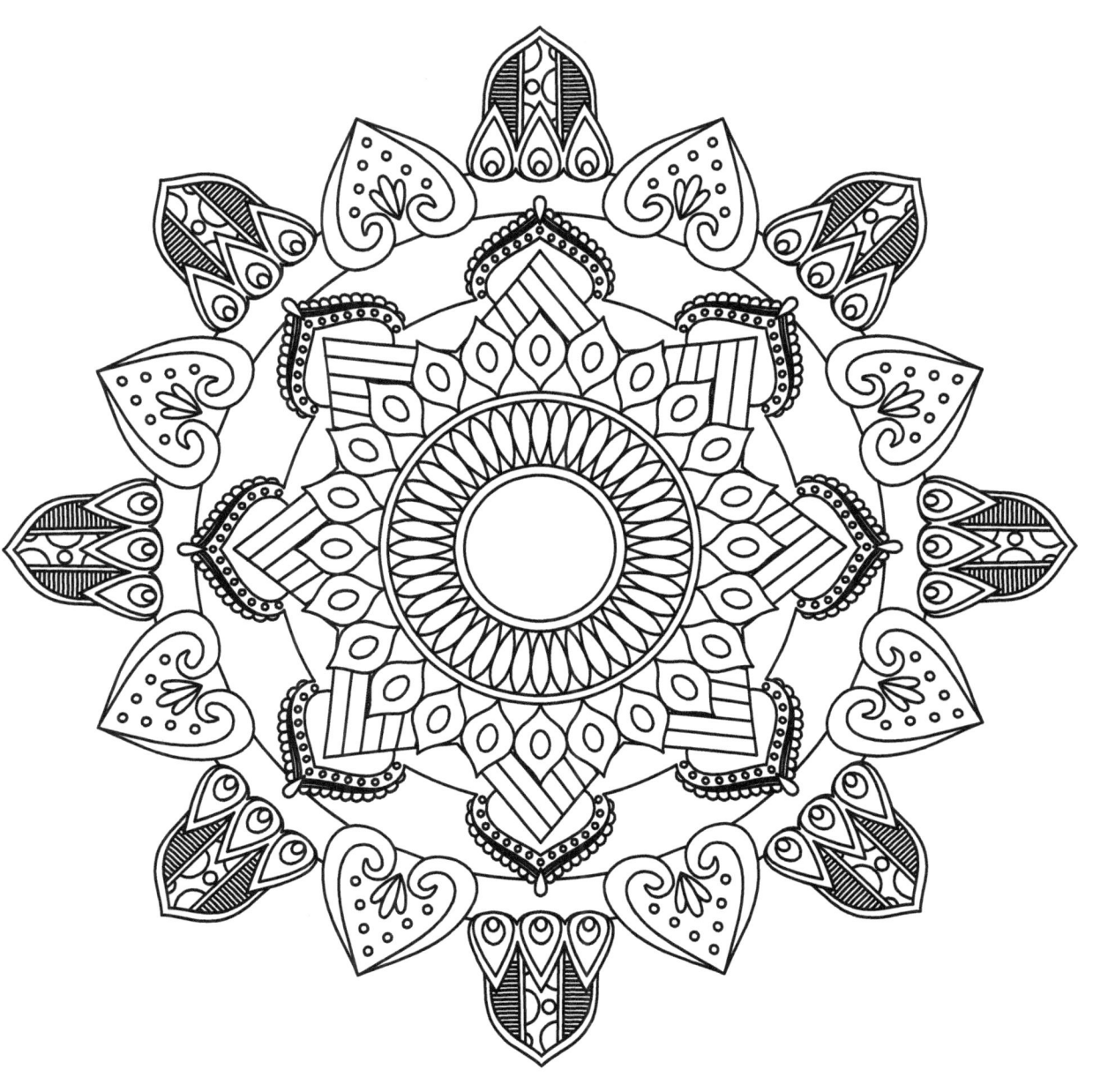

Calming Thoughts/Positive Affirmation:

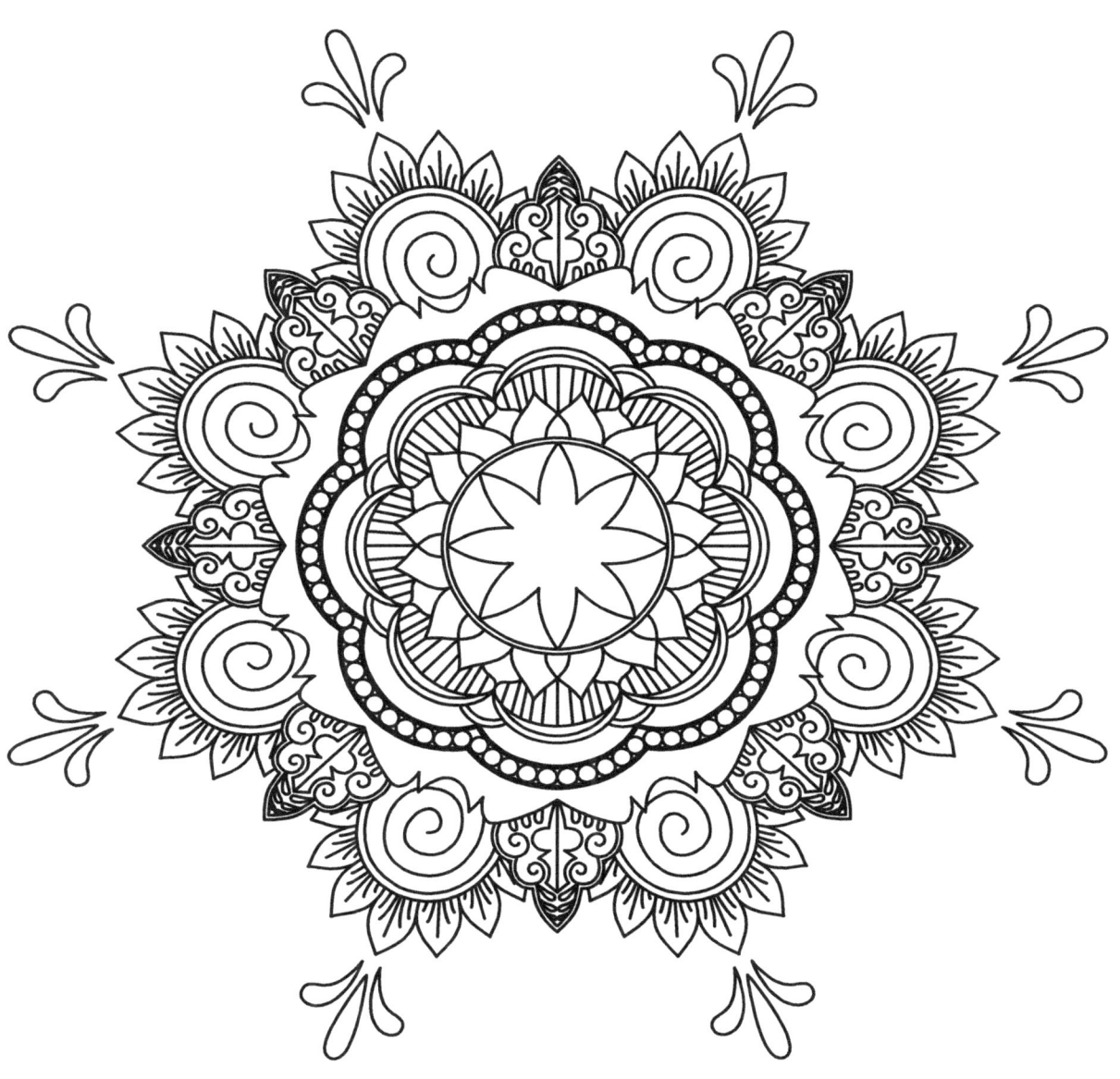

Calming Thoughts/Positive Affirmation:

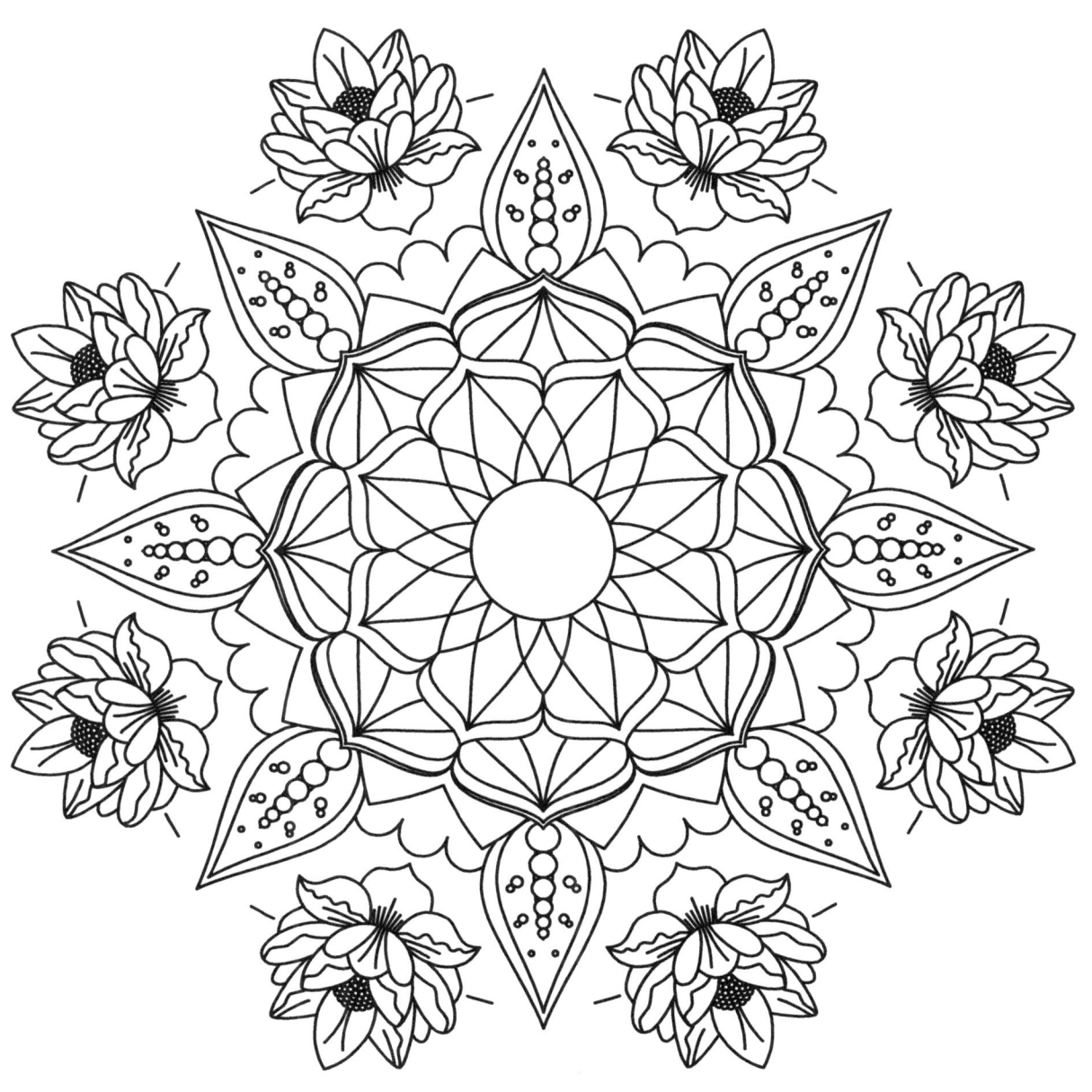

Calming Thoughts/Positive Affirmation:

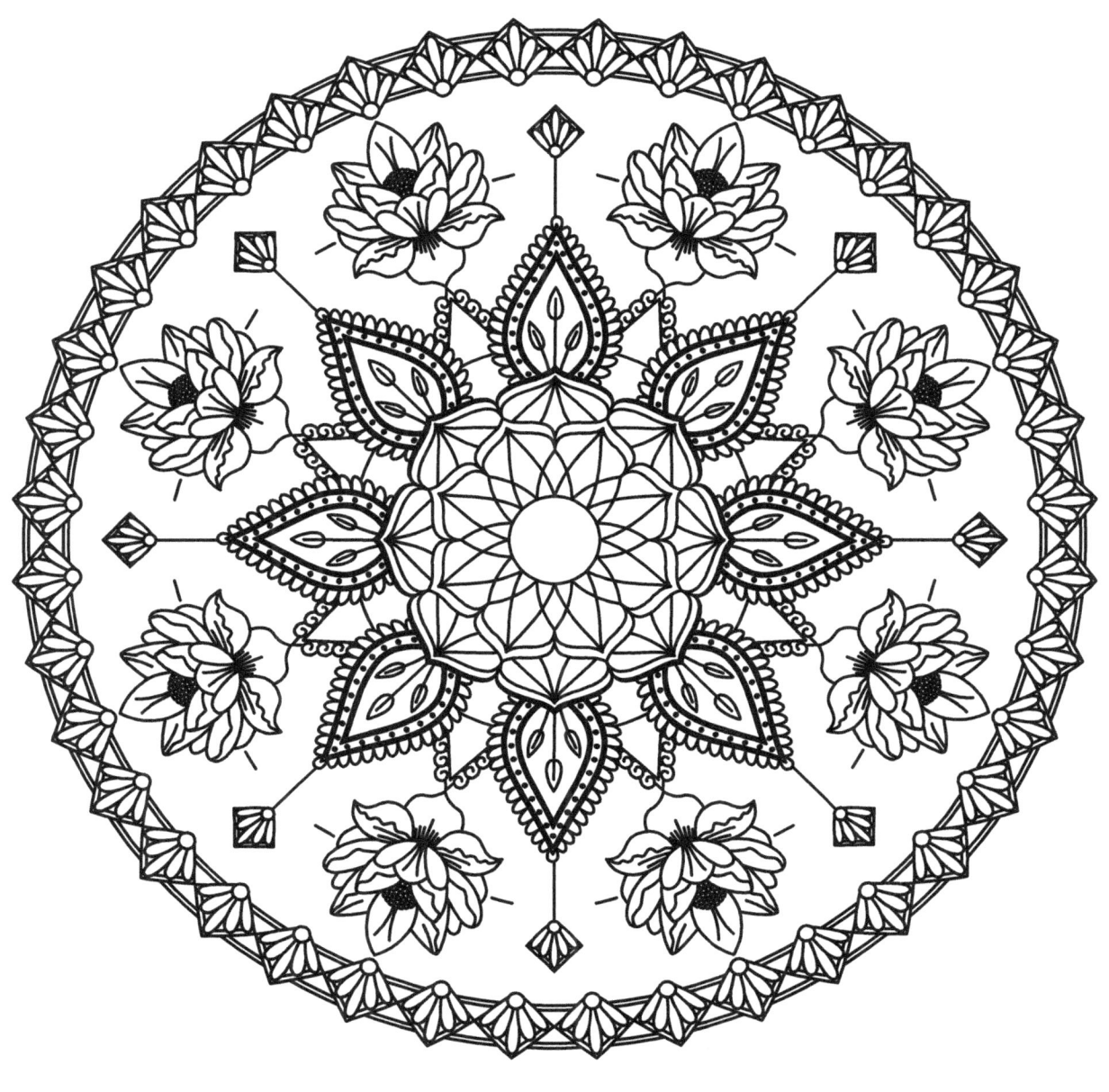

Calming Thoughts/Positive Affirmation:

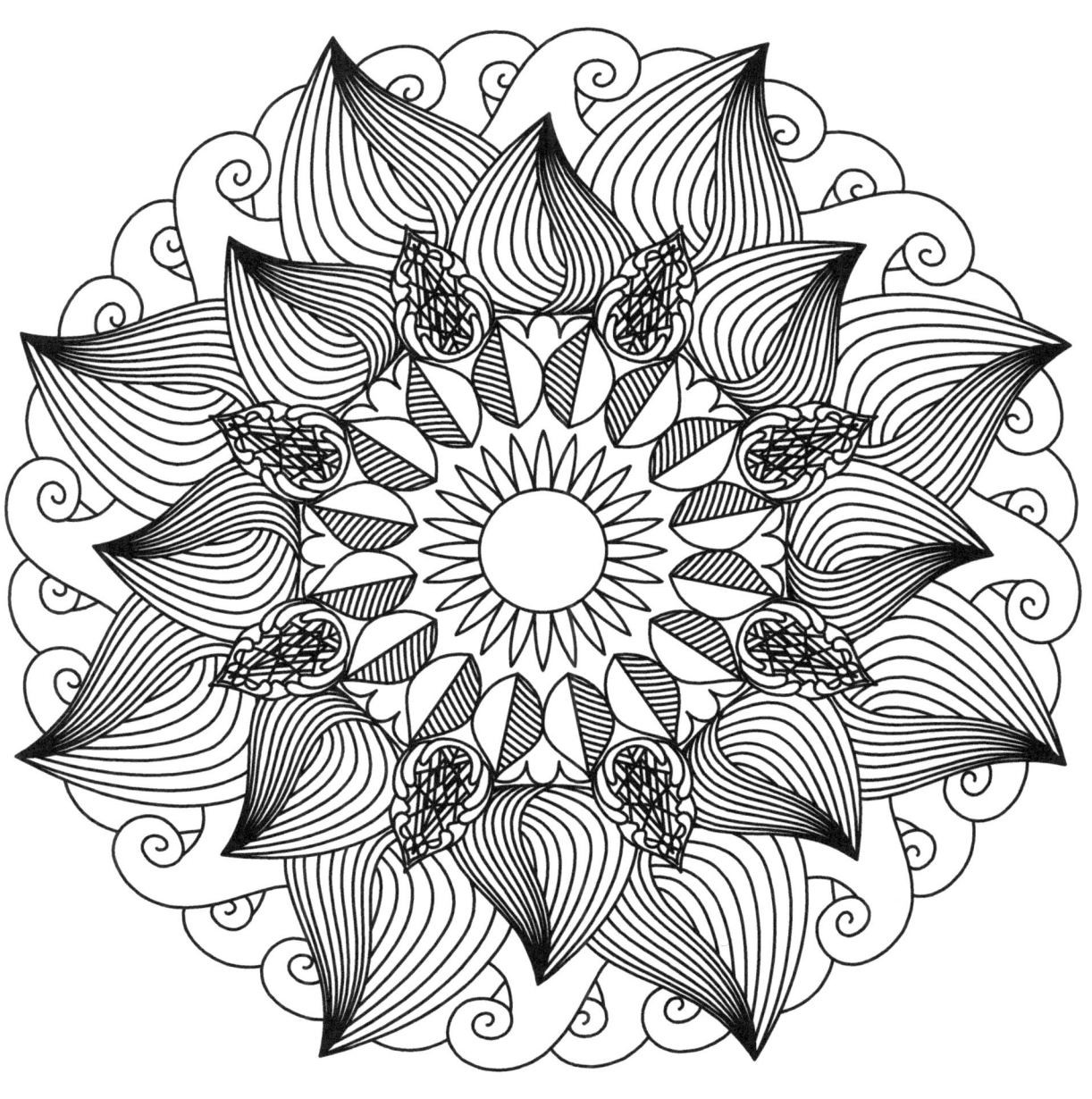

Calming Thoughts/Positive Affirmation:

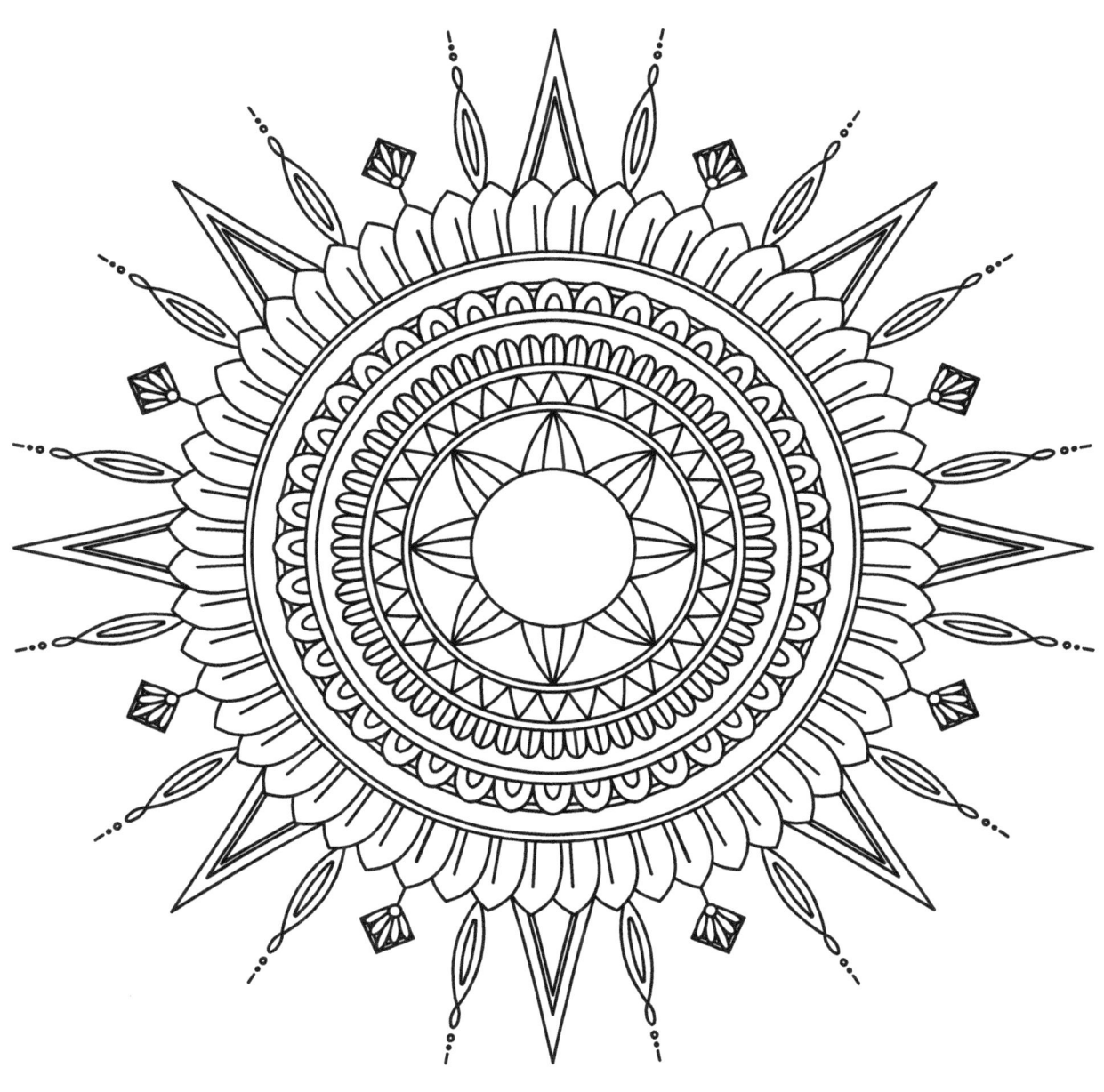

Calming Thoughts/Positive Affirmation:

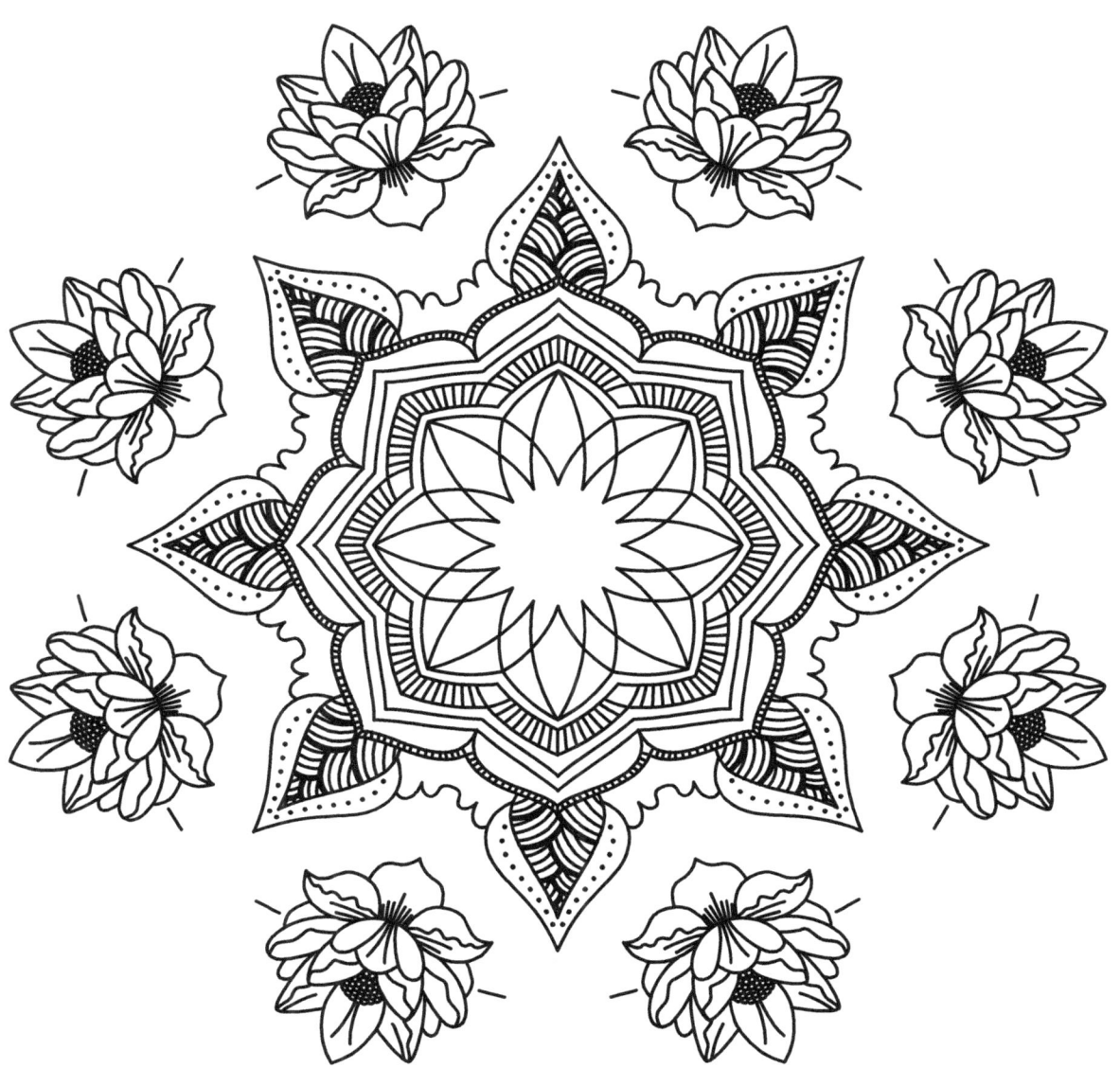

Calming Thoughts/Positive Affirmation:

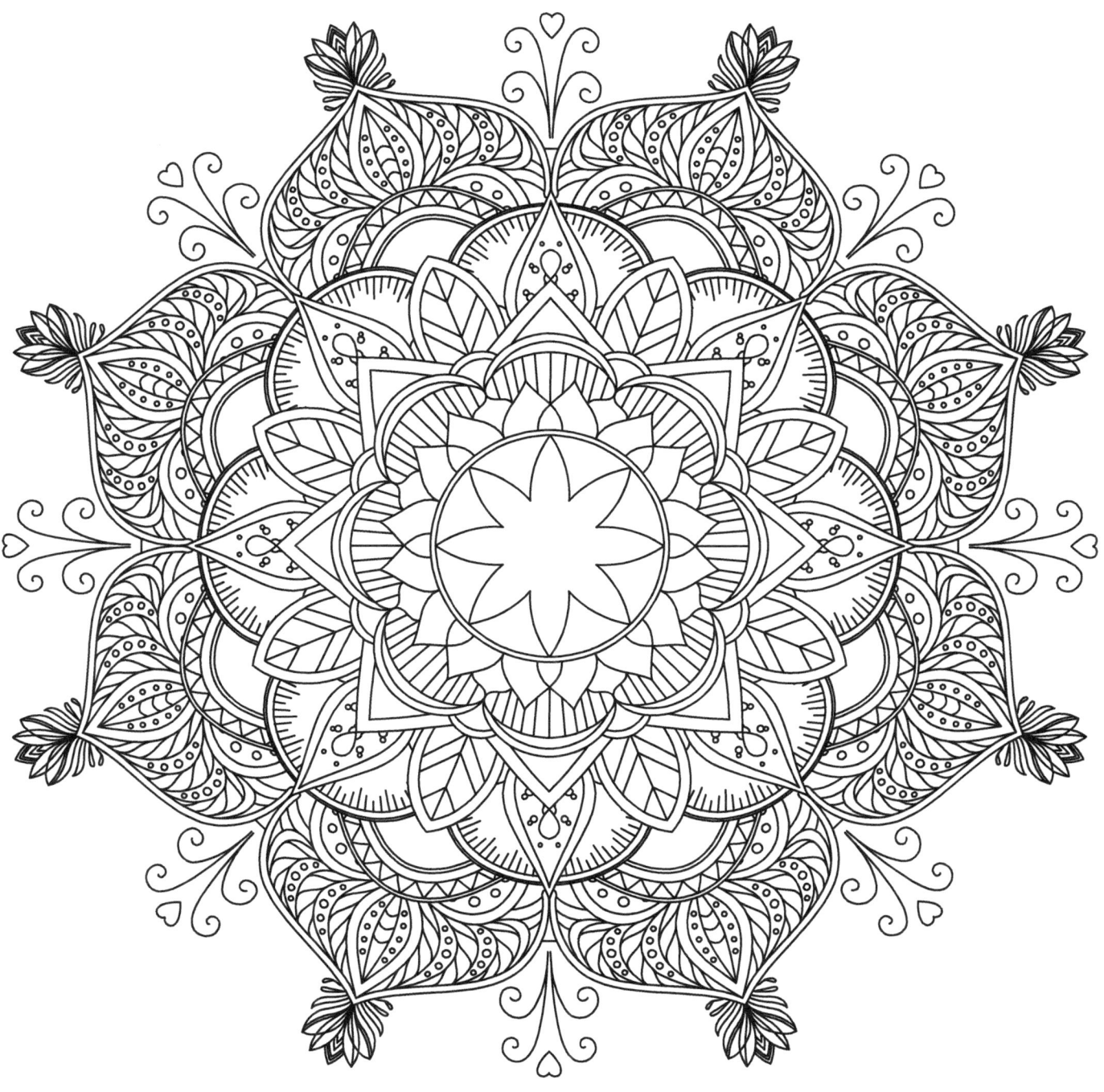

Calming Thoughts/Positive Affirmation:

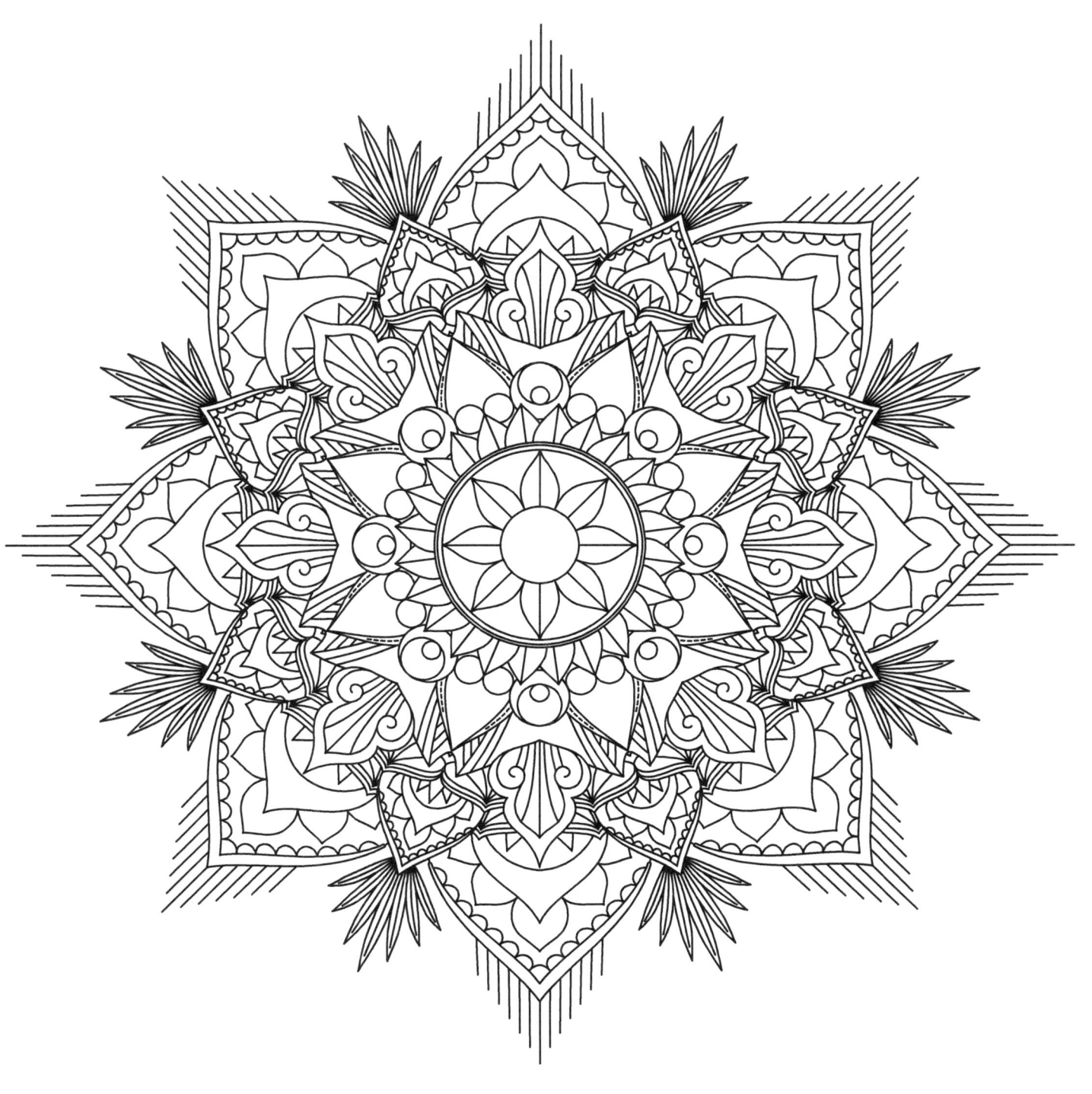

Calming Thoughts/Positive Affirmation:

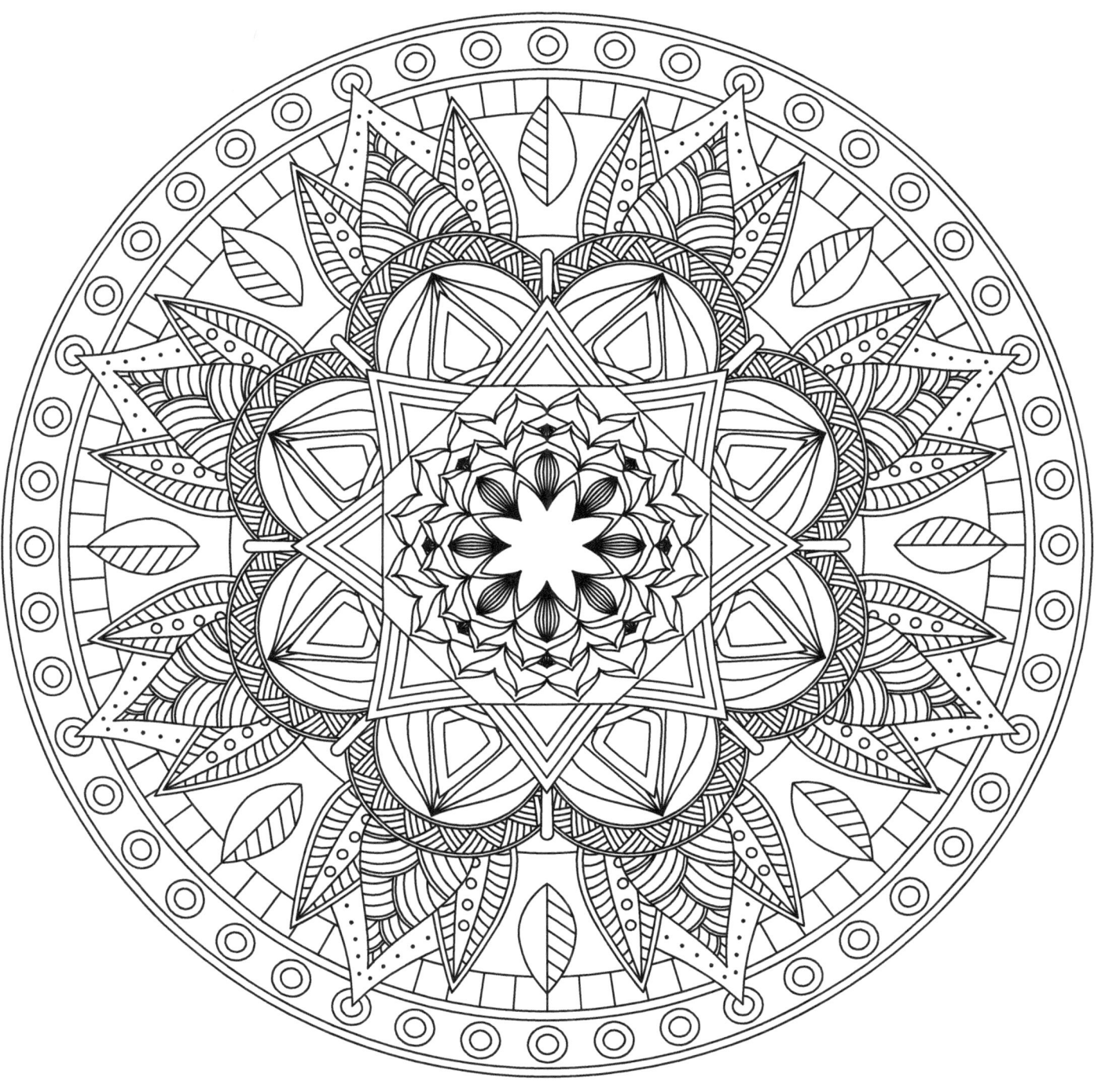

Calming Thoughts/Positive Affirmation:

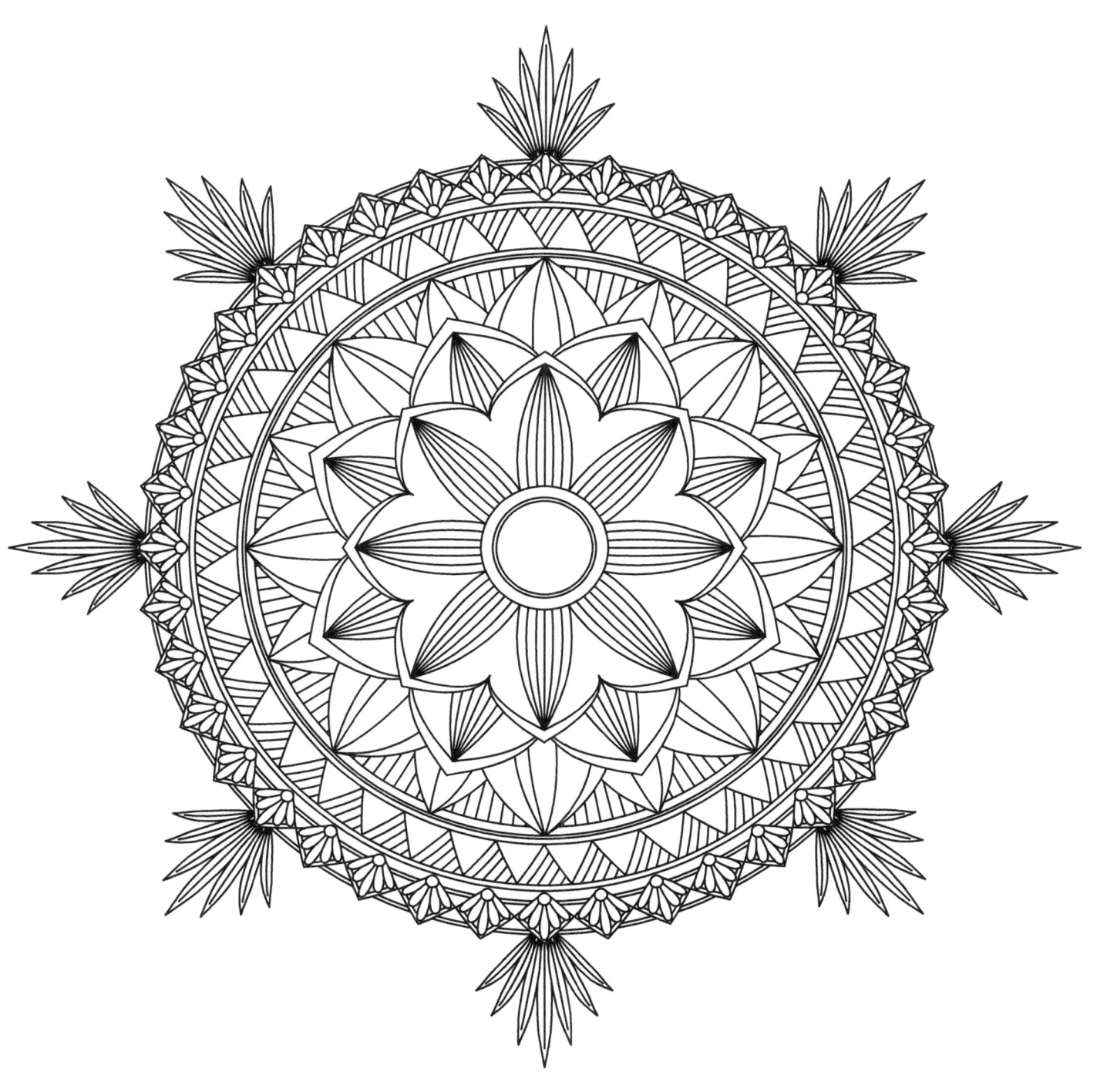

Calming Thoughts/Positive Affirmation:

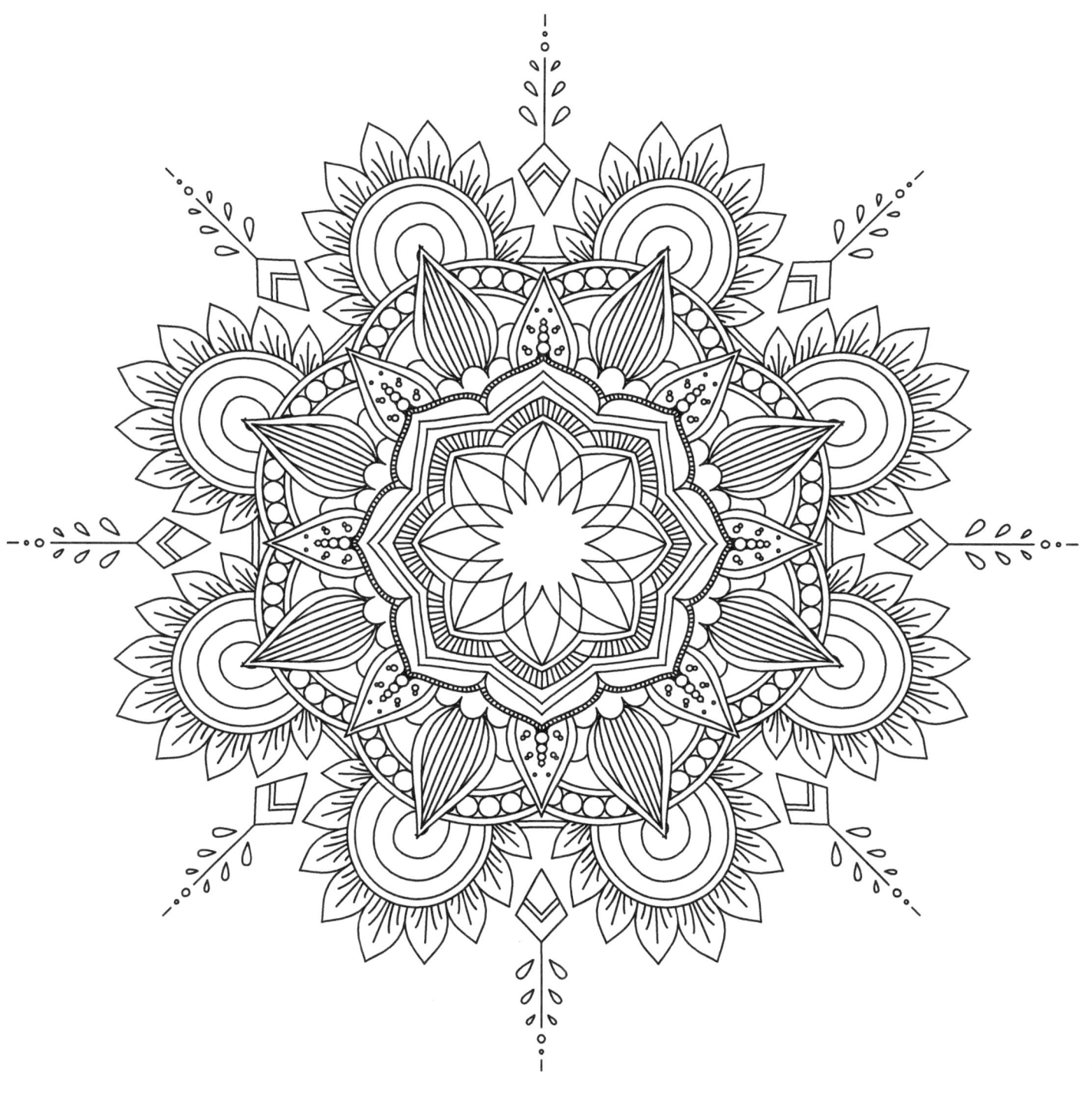

Calming Thoughts/Positive Affirmation:

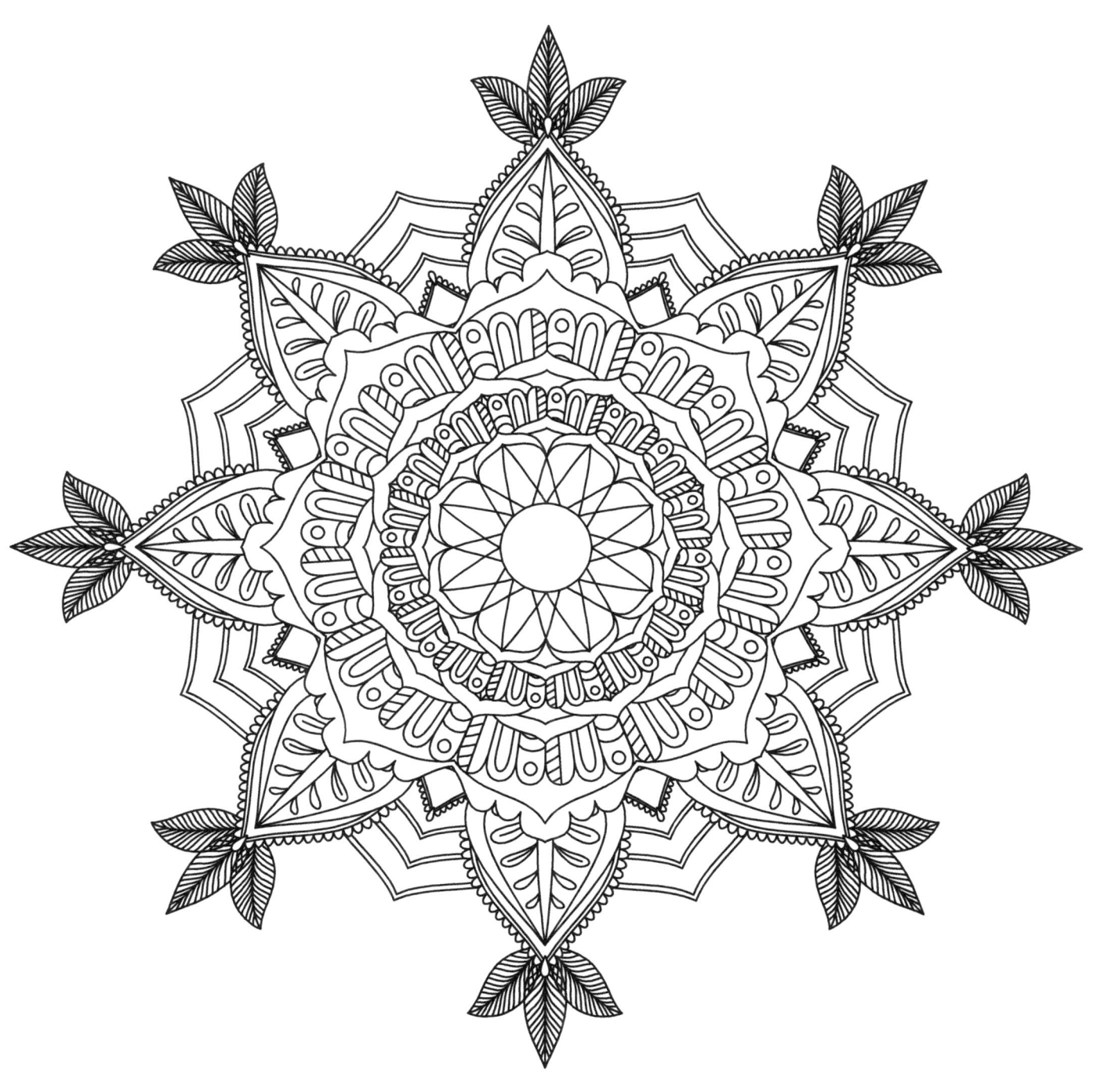

Calming Thoughts/Positive Affirmation:

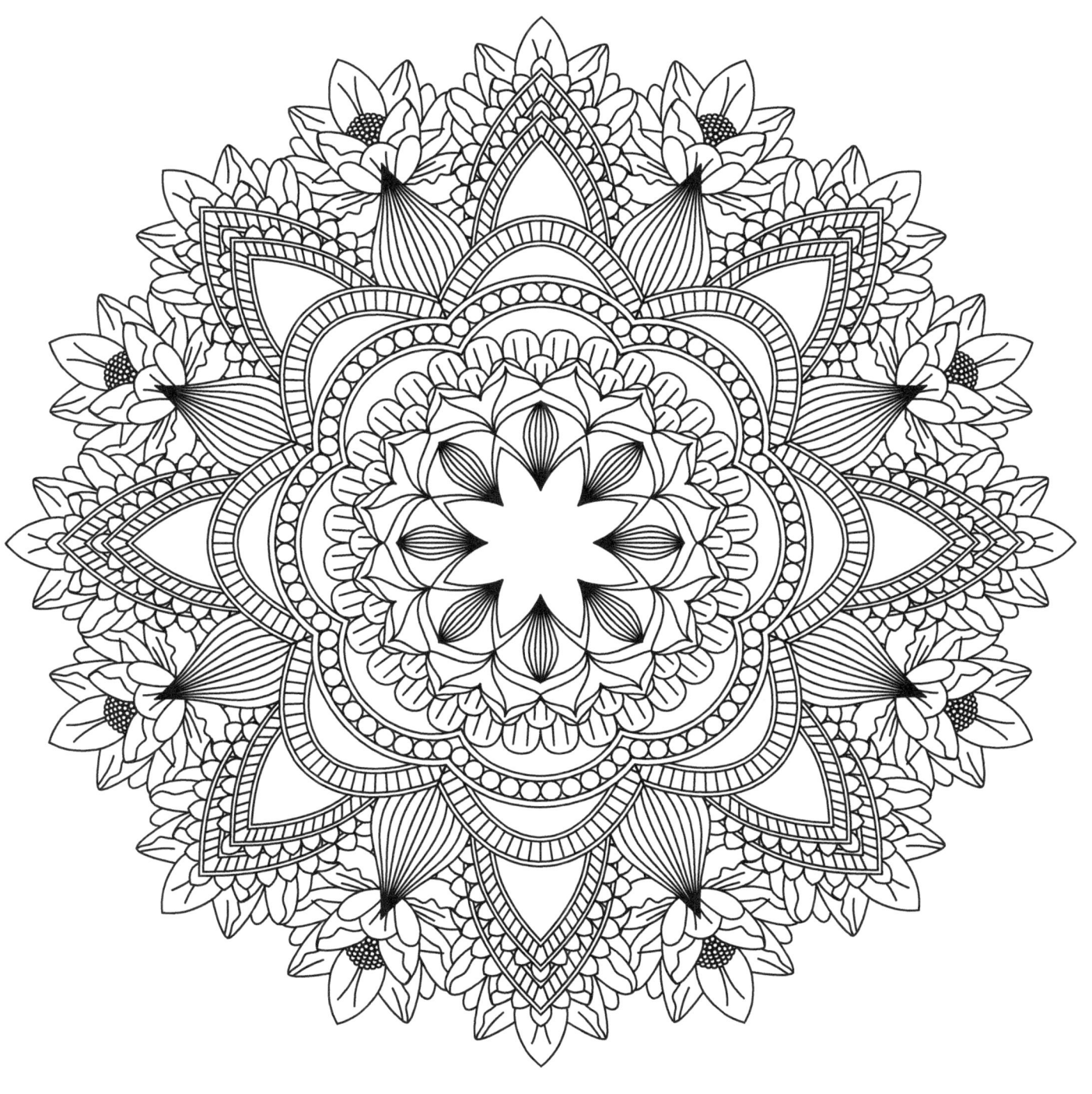

Calming Thoughts/Positive Affirmation:

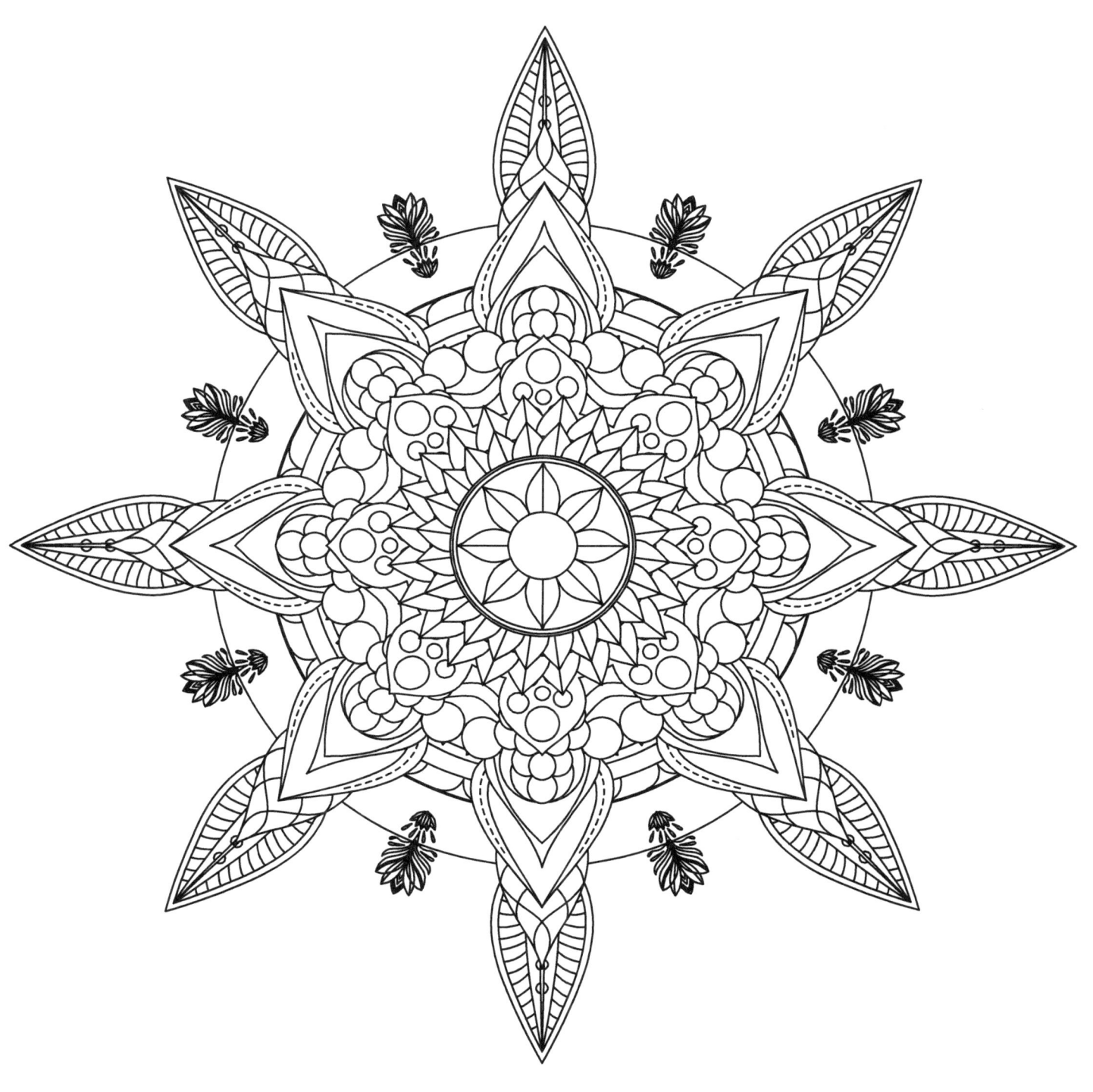

Calming Thoughts/Positive Affirmation:

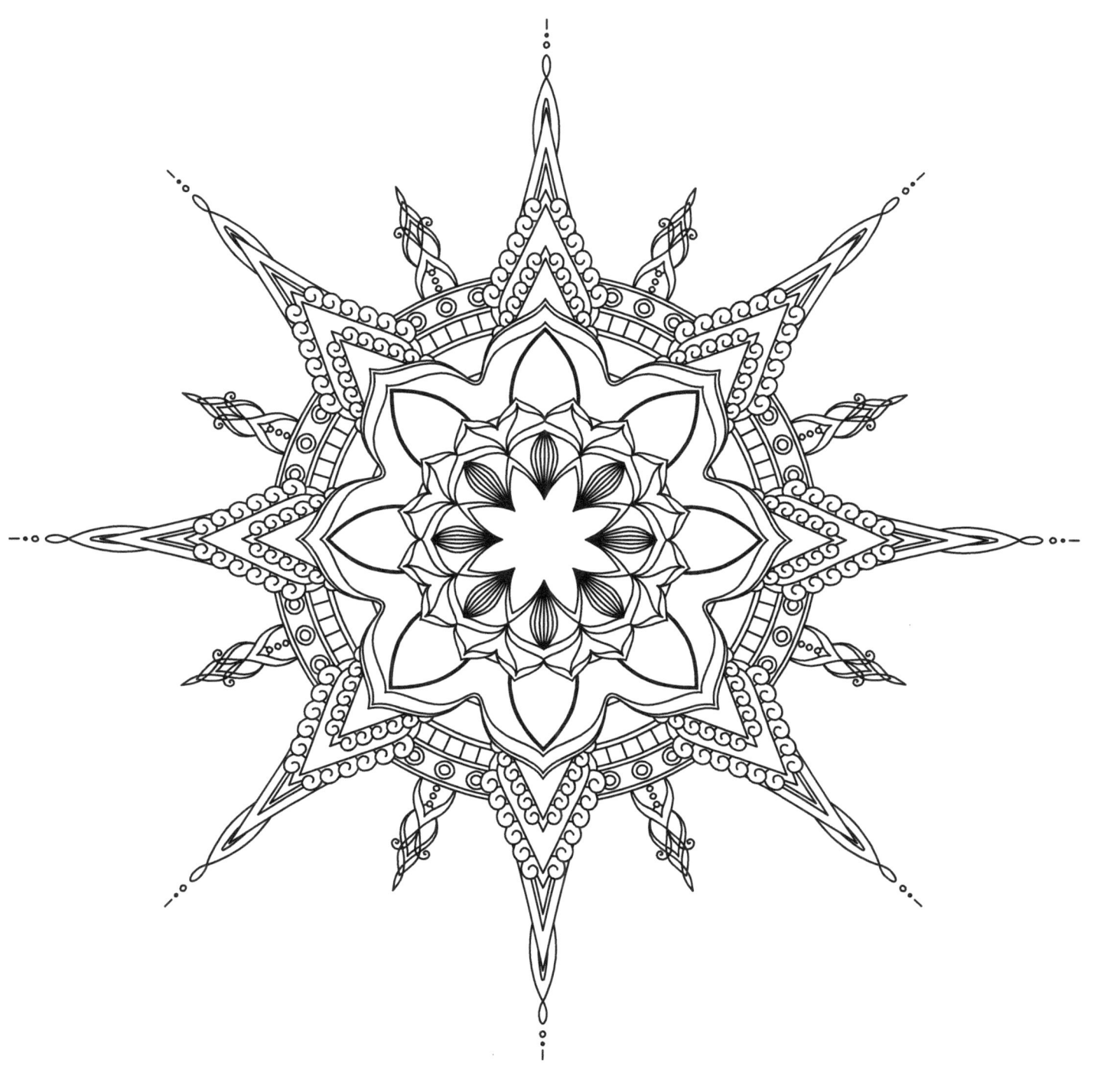

Calming Thoughts/Positive Affirmation:

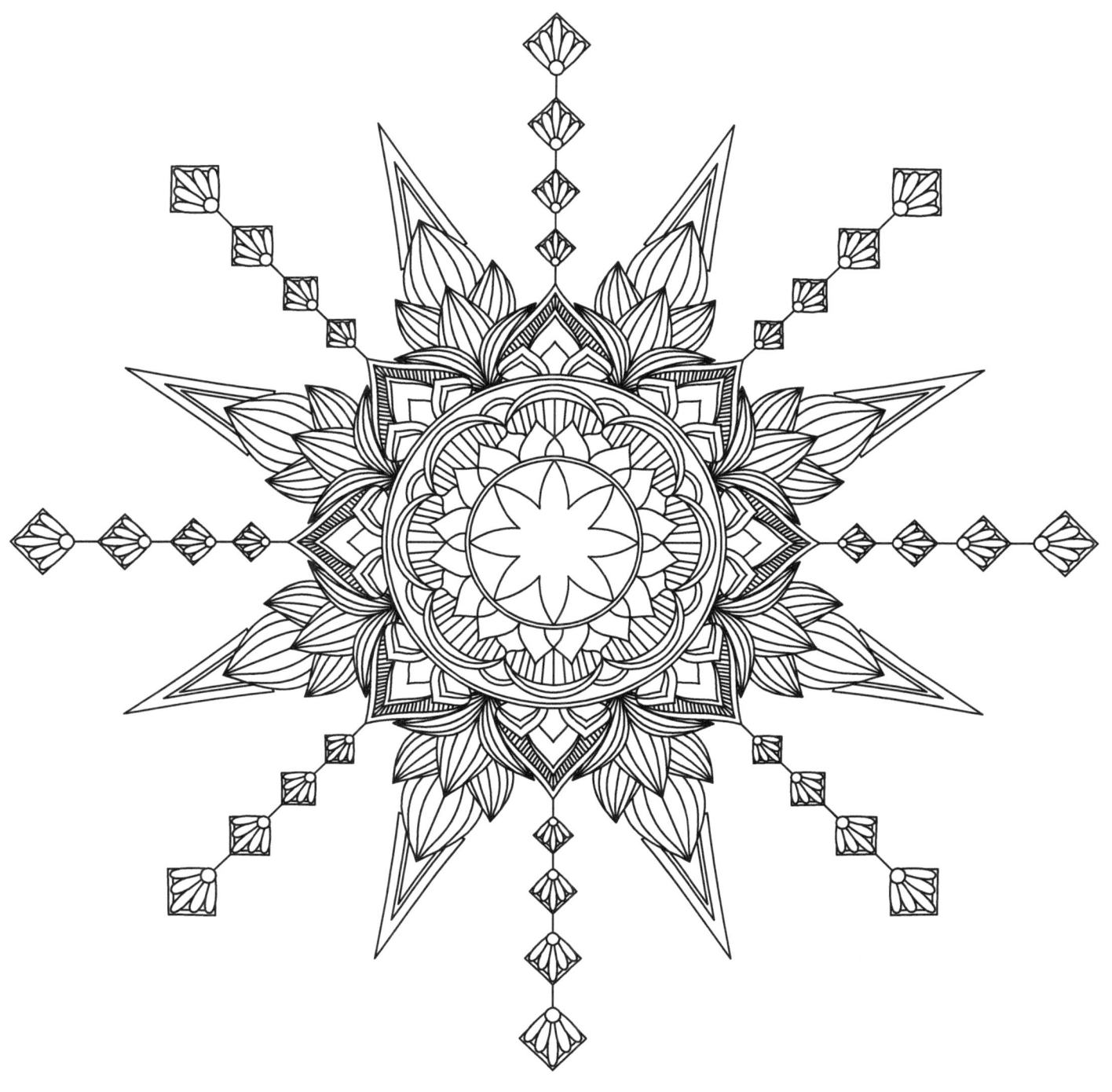

Calming Thoughts/Positive Affirmation:

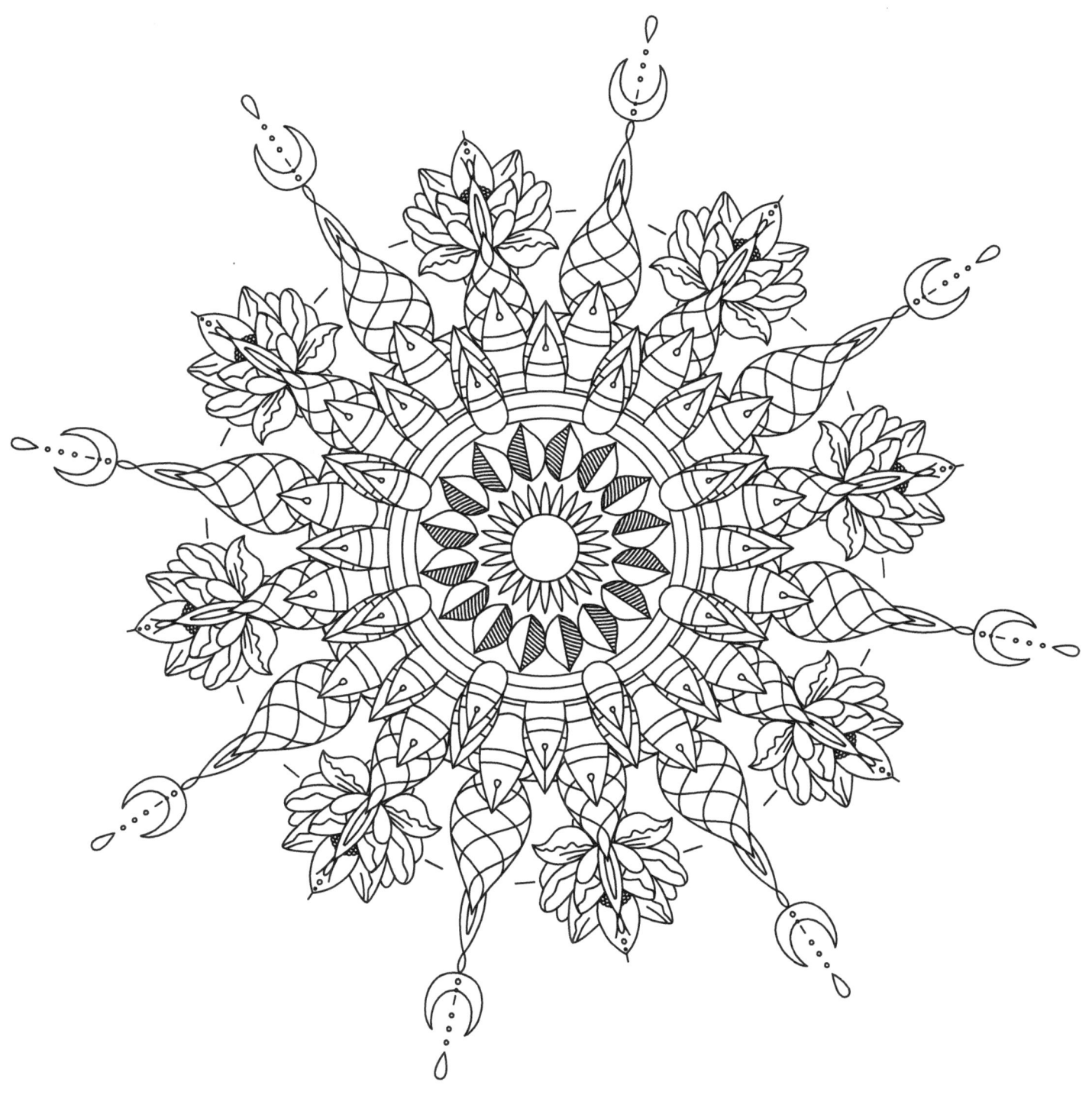

Calming Thoughts/Positive Affirmation:

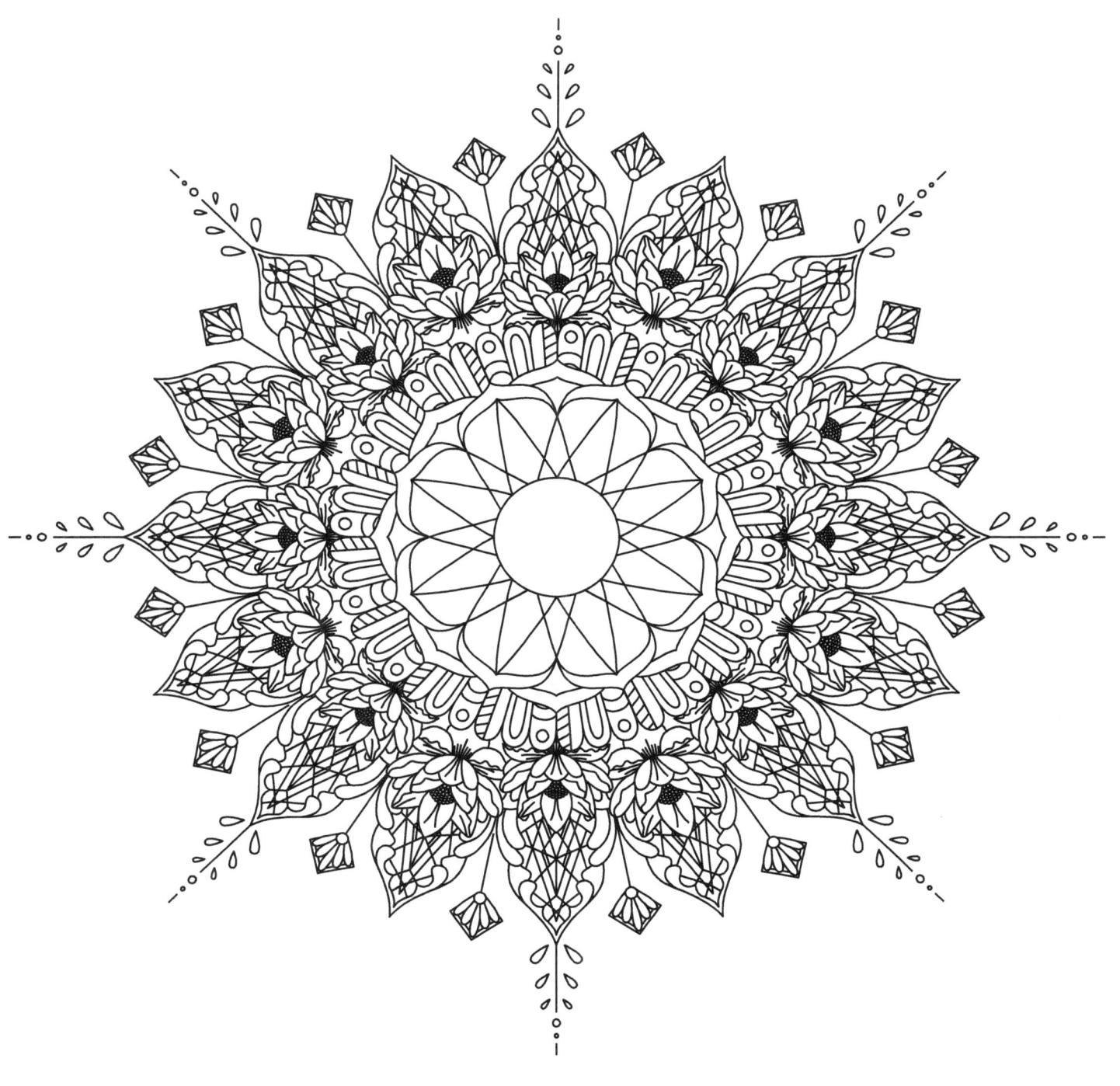

Calming Thoughts/Positive Affirmation:

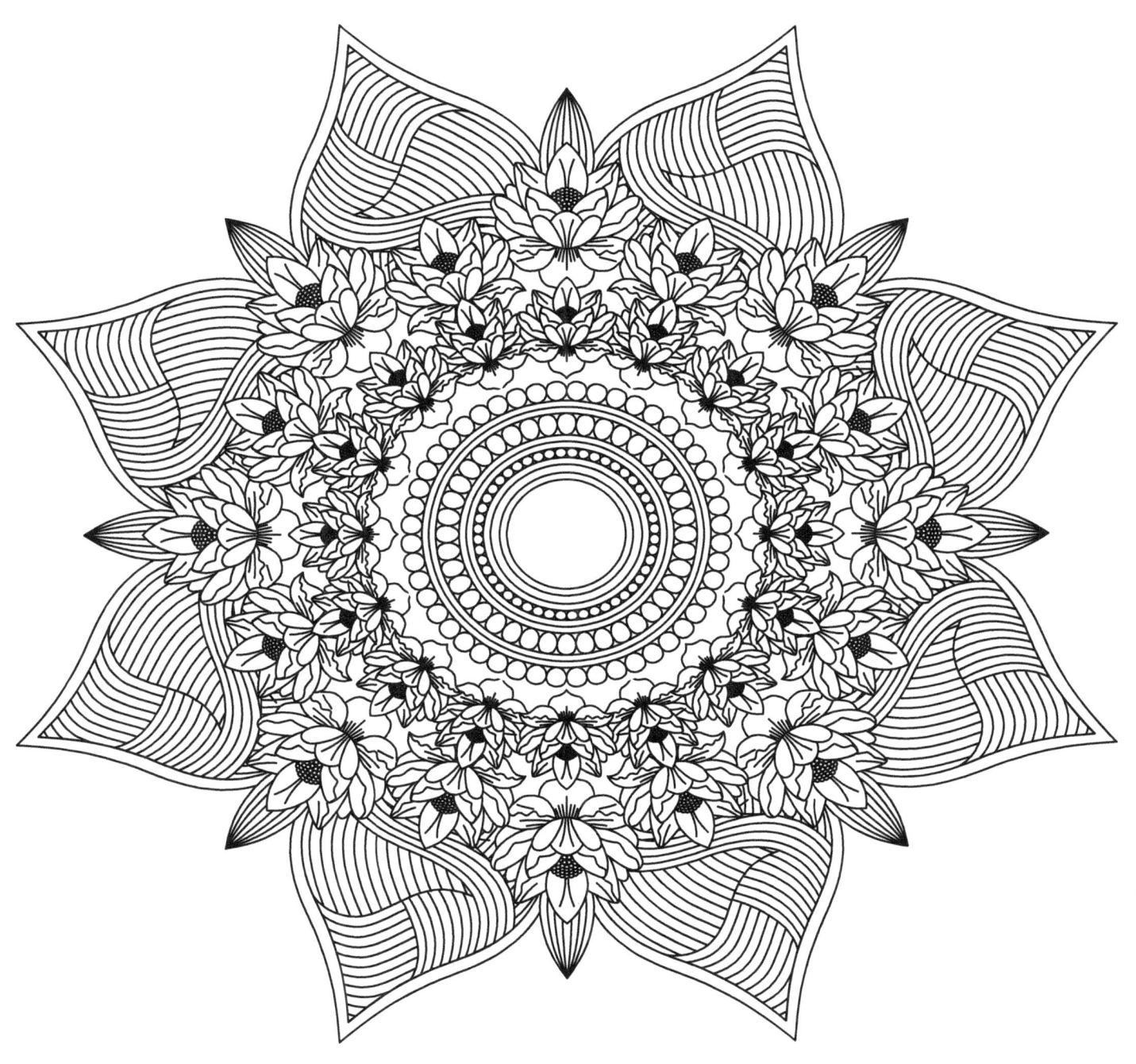

Calming Thoughts/Positive Affirmation:

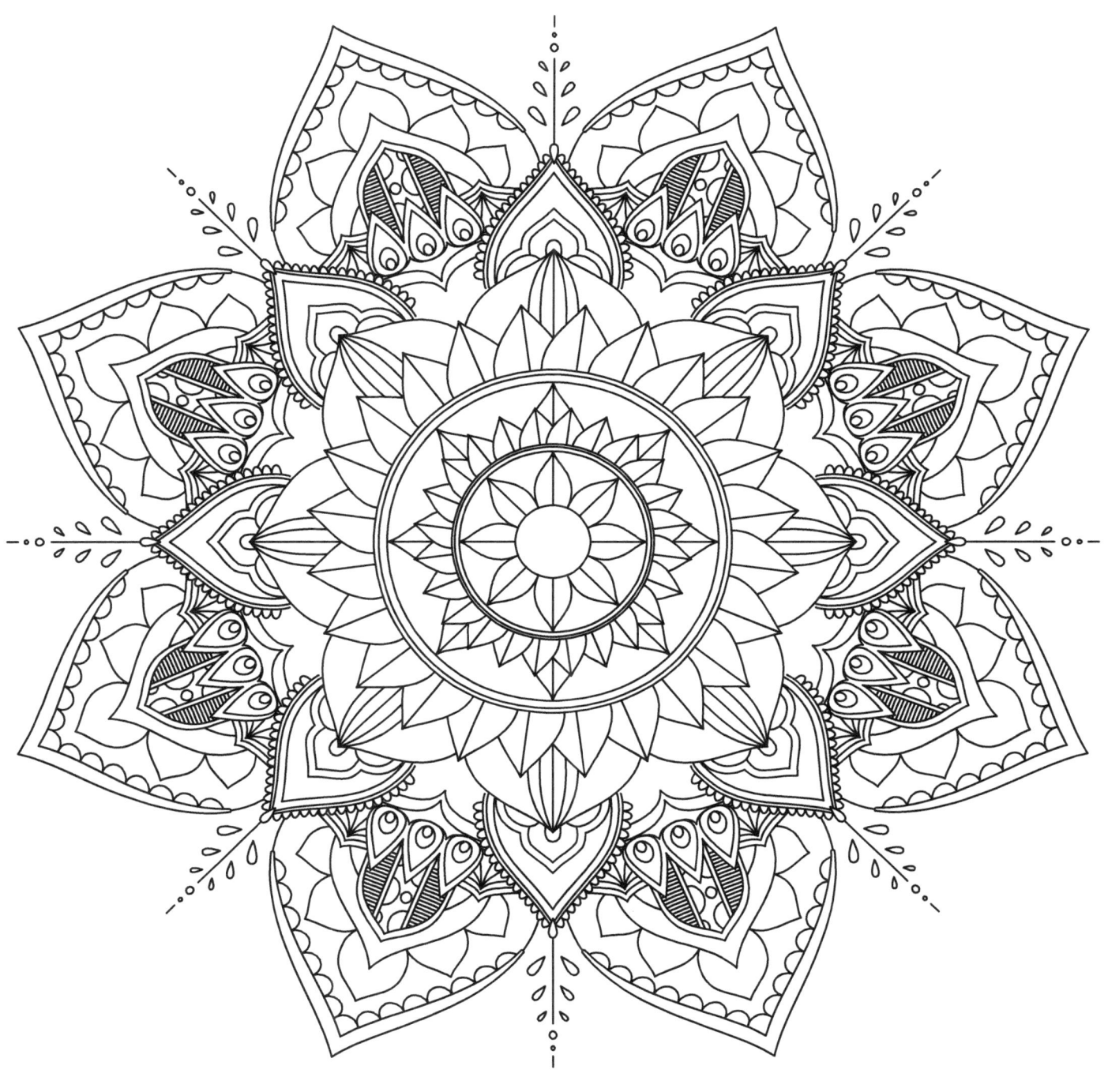

Calming Thoughts/Positive Affirmation:

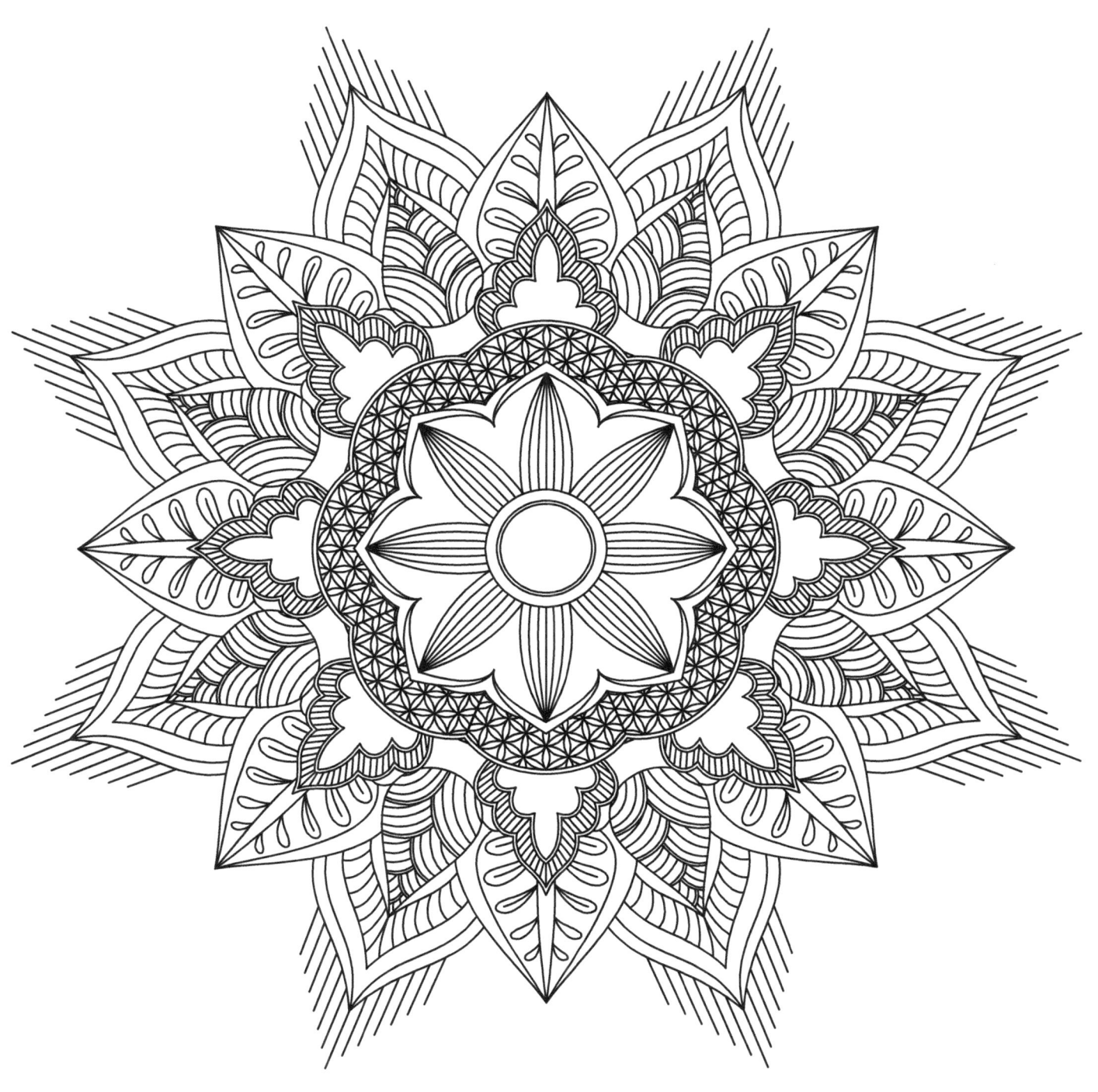

Calming Thoughts/Positive Affirmation:

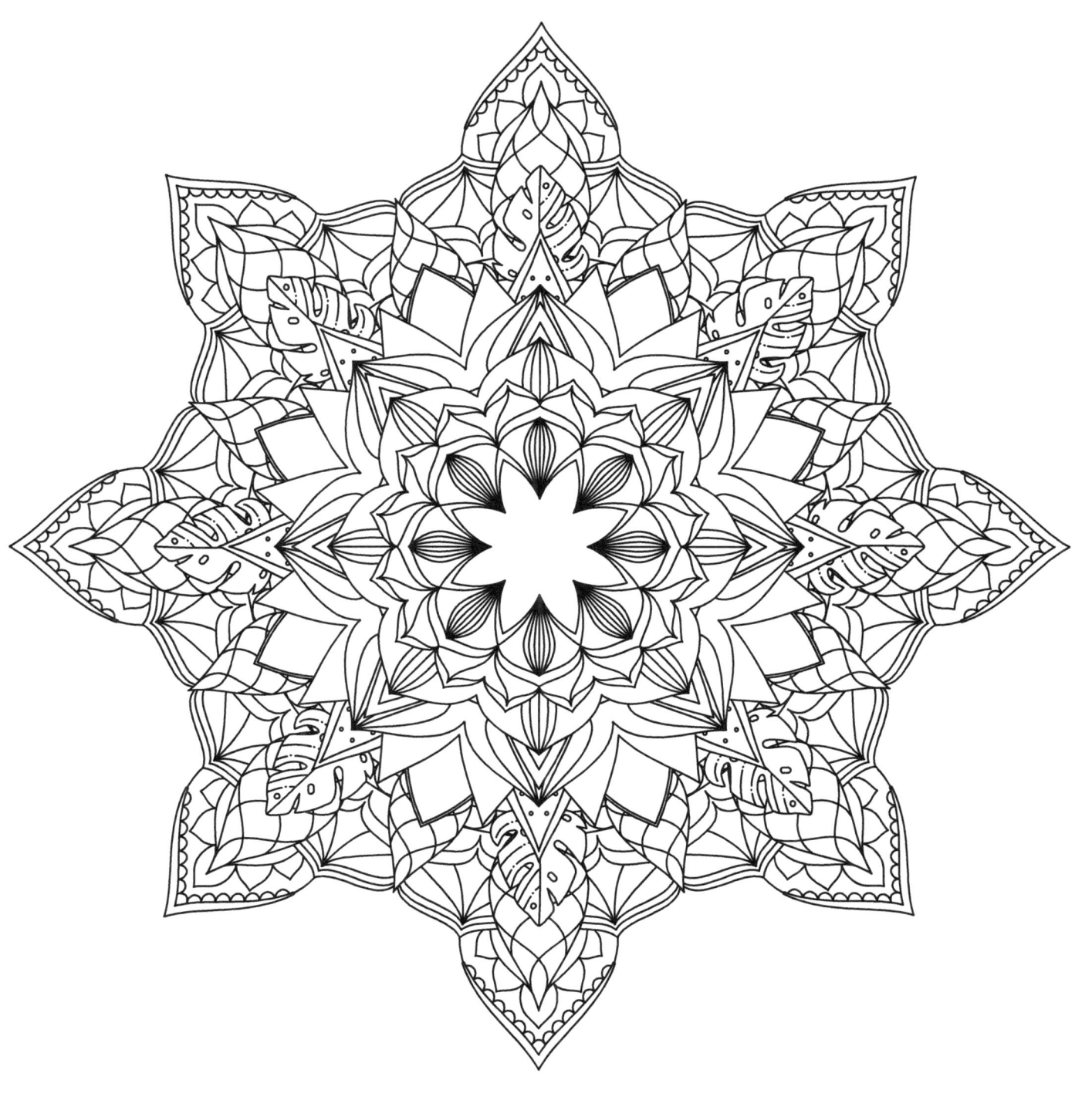

Calming Thoughts/Positive Affirmation:

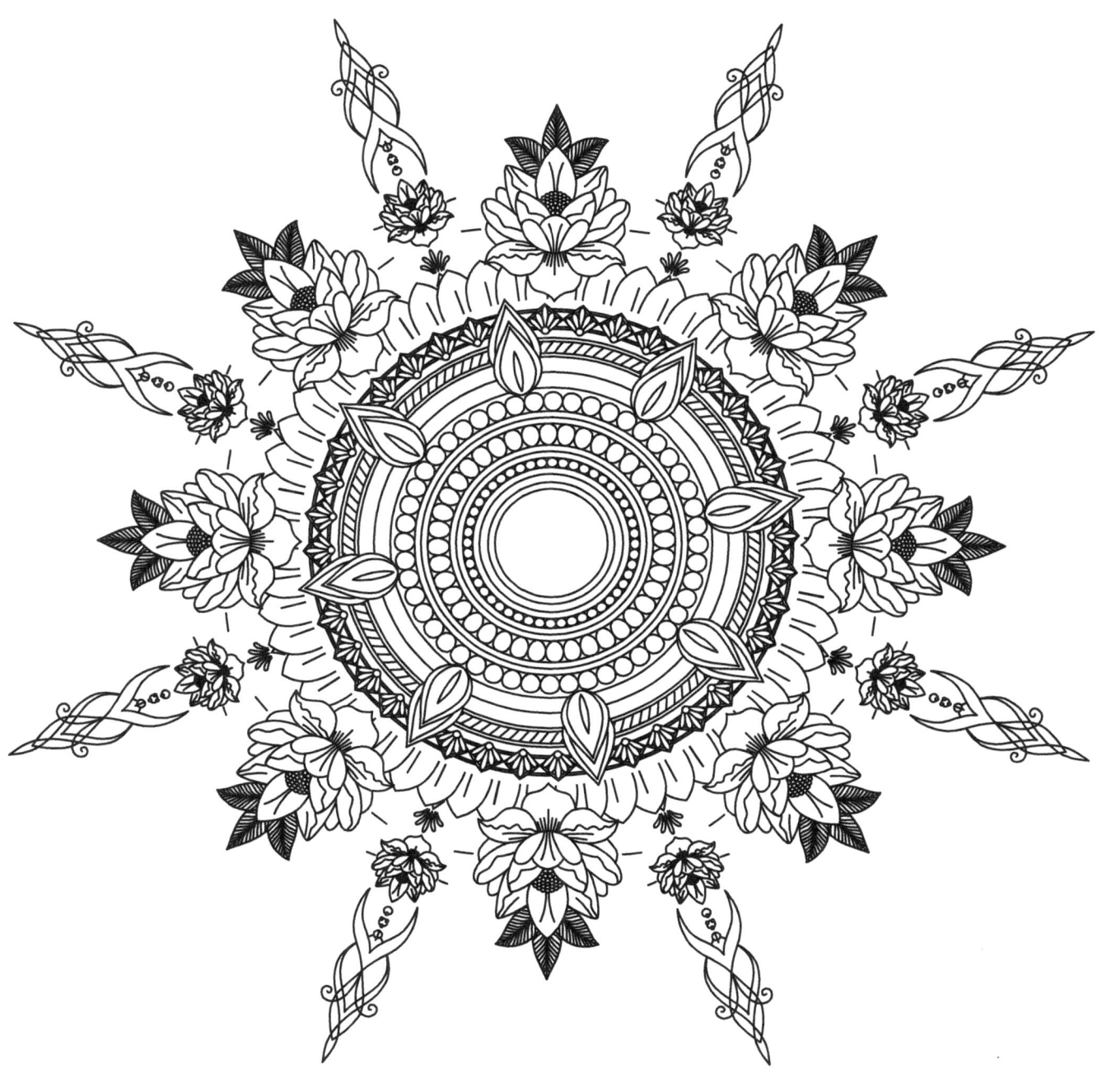

Calming Thoughts/Positive Affirmation:

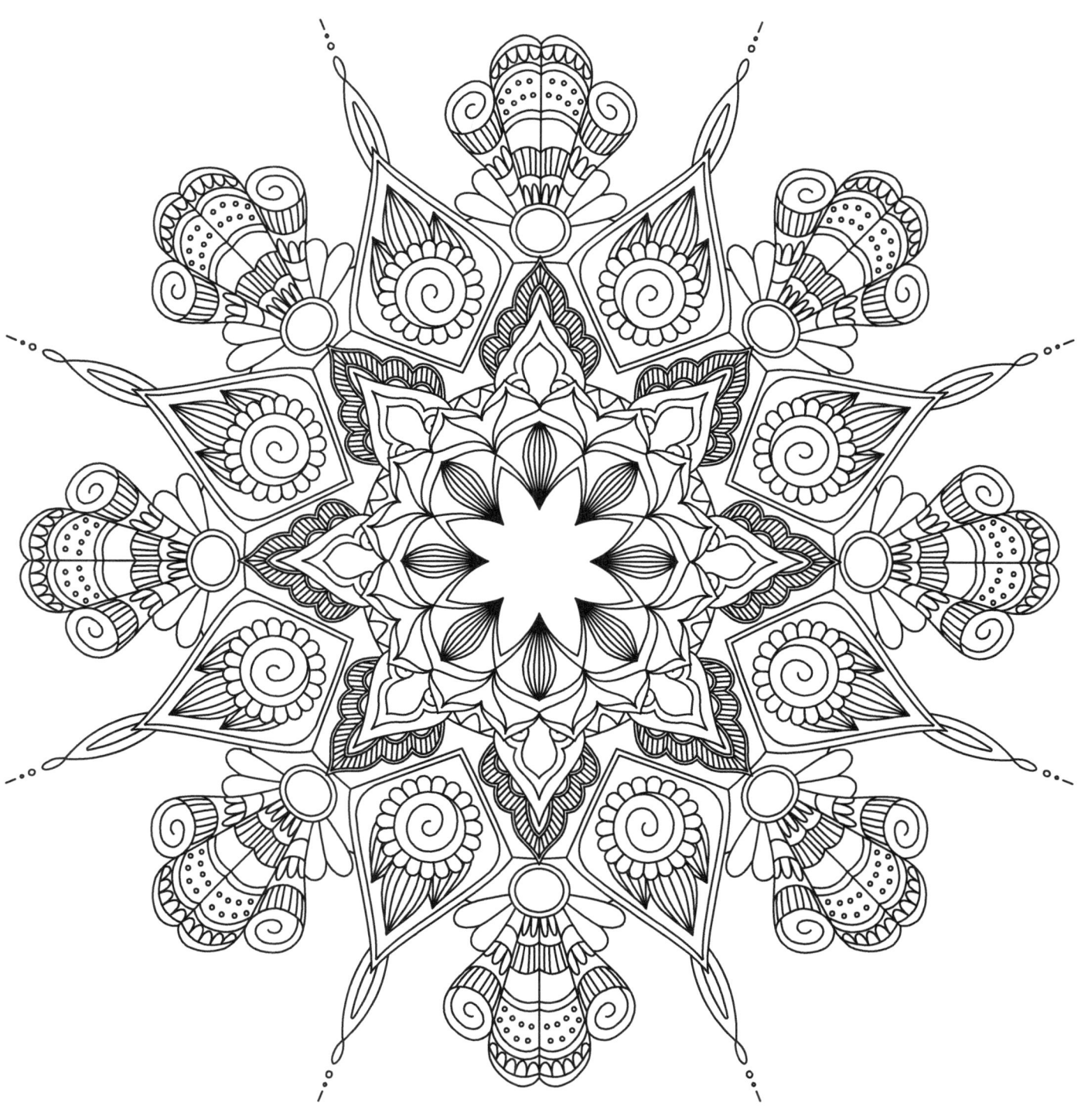

Calming Thoughts/Positive Affirmation:

www.ingramcontent.com/pod-product-compliance
Lightning Source LLC
Chambersburg PA
CBHW080940170526

45158CB00008B/2317